LAUGHING

WITH OBAMA

LAUGHING

WITH OBAMA

A Photographic Look Back at the Enduring Wit and Spirit of

PRESIDENT BARACK OBAMA

EDITED BY M. SWEENEY

CASTLE POINT BOOKS

NEW YORK

www.stmartins.com
www.castlepointbooks.com

The Castle Point Books trademark is owned by Castle Point Publishing, LLC.
Castle Point books are published and distributed by St. Martin's Press.

Design by Katie Jennings Campbell

Cover Photo: Image used by permission. Photo credit: Tim Schoon
Interior Photos: United States Government Works / Official White House Photos
by Chuck Kennedy, Amanda Lucidon, and Pete Souza

ISBN 978-1-250-23460-5 (hardcover)
ISBN 978-1-250-23459-9 (e-book)

Our books may be purchased in bulk for promotional, educational, or business use.
Please contact your local bookseller or the Macmillan Corporate and
Premium Sales Department at 1-800-221-7945, extension 5442,
or by email at MacmillanSpecialMarkets@macmillan.com.

First Edition: September 2019

10 9 8 7 6 5 4 3 2 1

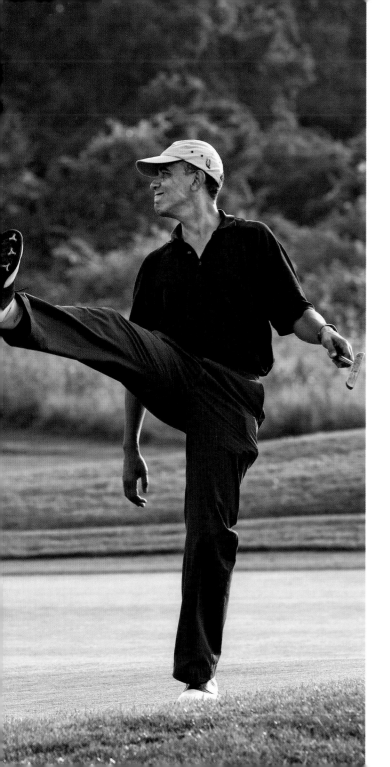

CONTENTS

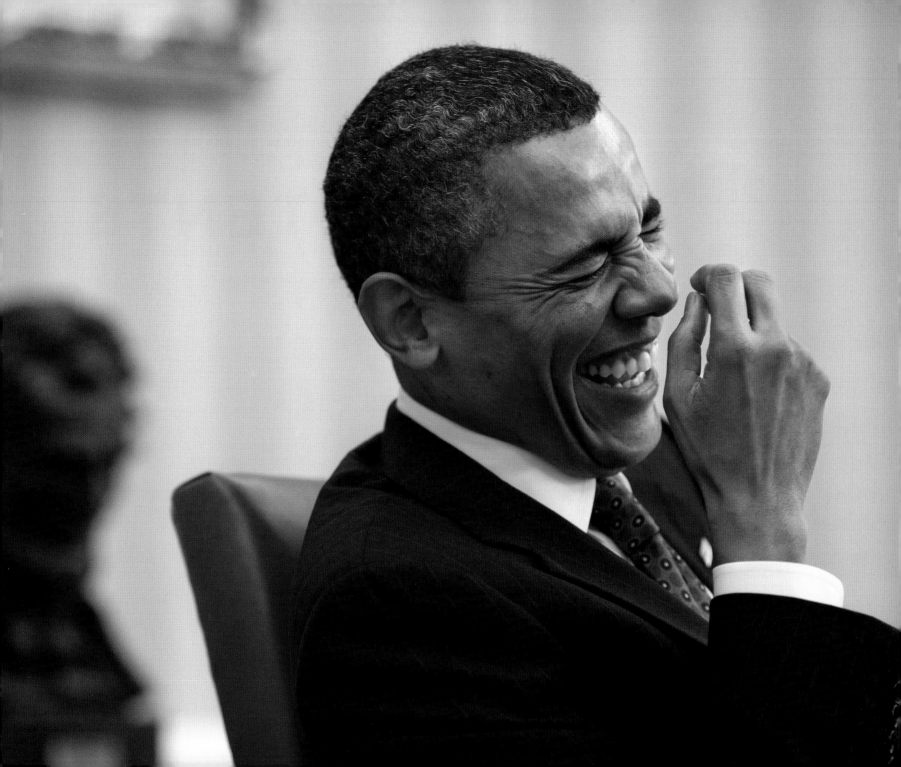

INTRODUCTION

TAKE A LOOK BACK AT A PRESIDENCY that was not just historic, but immeasurably uplifting. As the 44th President of the United States, Barack Obama was a unifying force and an inspiring leader, a family man, and a friend to the citizens of his country and the world. Always ready with a joke, an easy smile, and boatloads of breezy confidence, Barack Obama's power to charm was as considerable as his power to lead. If there were a leader we dreamed of inviting over to dinner, it would be President Obama.

Laughing with Obama is a photographic celebration of the most heartwarming, playful, and humorous moments of Barack Obama's time in the Oval Office. Each snapshot of President Obama in his element is accompanied by a witticism, clever punchline, or spirited quotation from the president himself. President Obama's good-humored efforts to reach across the aisle, support the citizens of the country, build friendships, and have a little fun are the hallmarks of his tenure. Pore over the pages that follow and be entertained by the humor and charisma of the former leader of the free world, President Barack Obama.

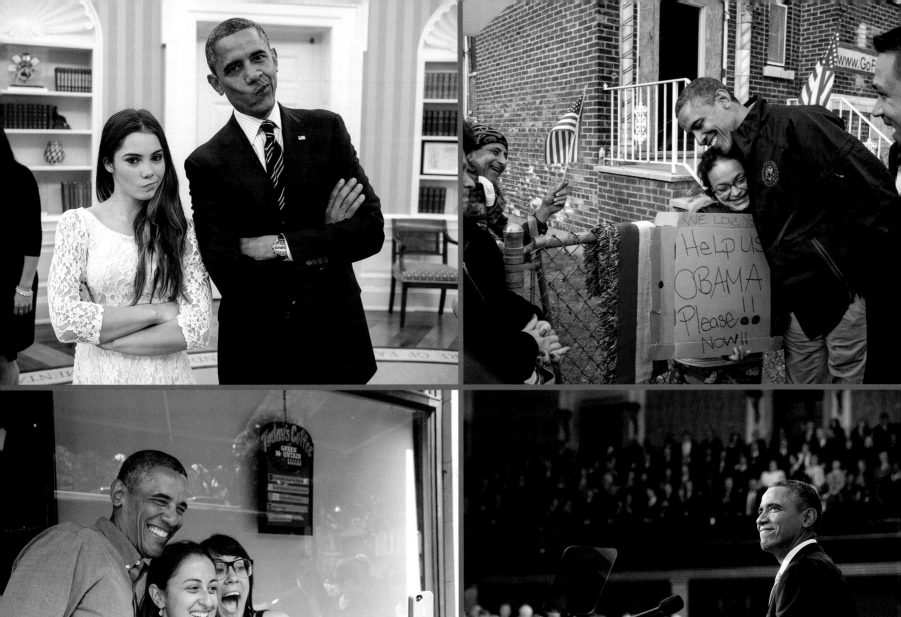

POLITICS

"Eight years ago, I said it was time to change the tone of our politics. In hindsight, **I CLEARLY SHOULD HAVE BEEN MORE SPECIFIC.**"

—White House Correspondents' Association Dinner, April 30, 2016

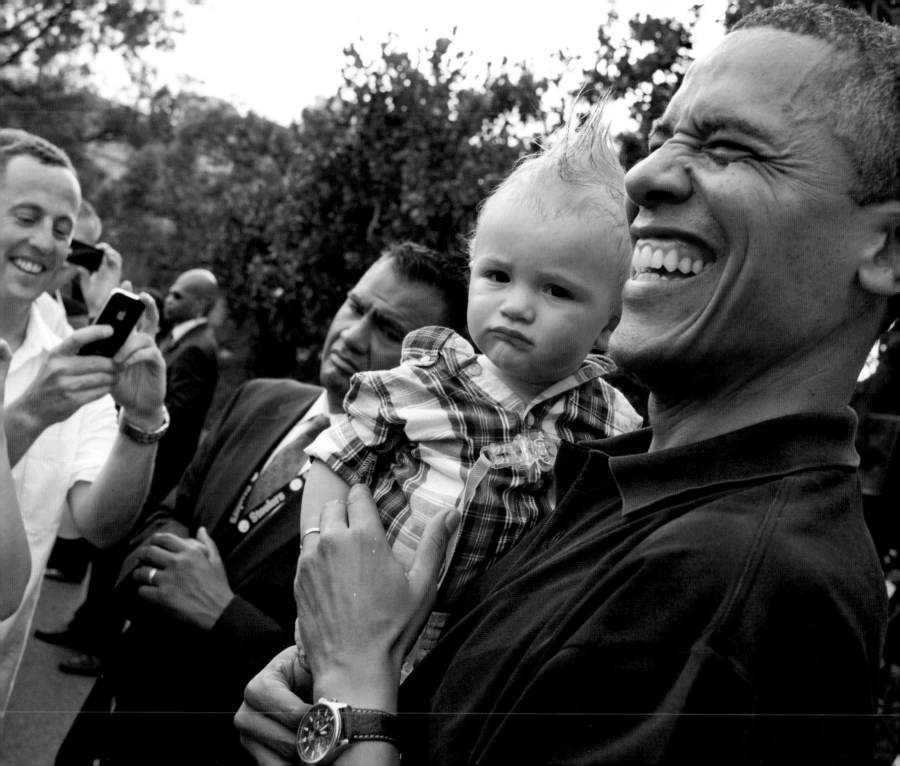

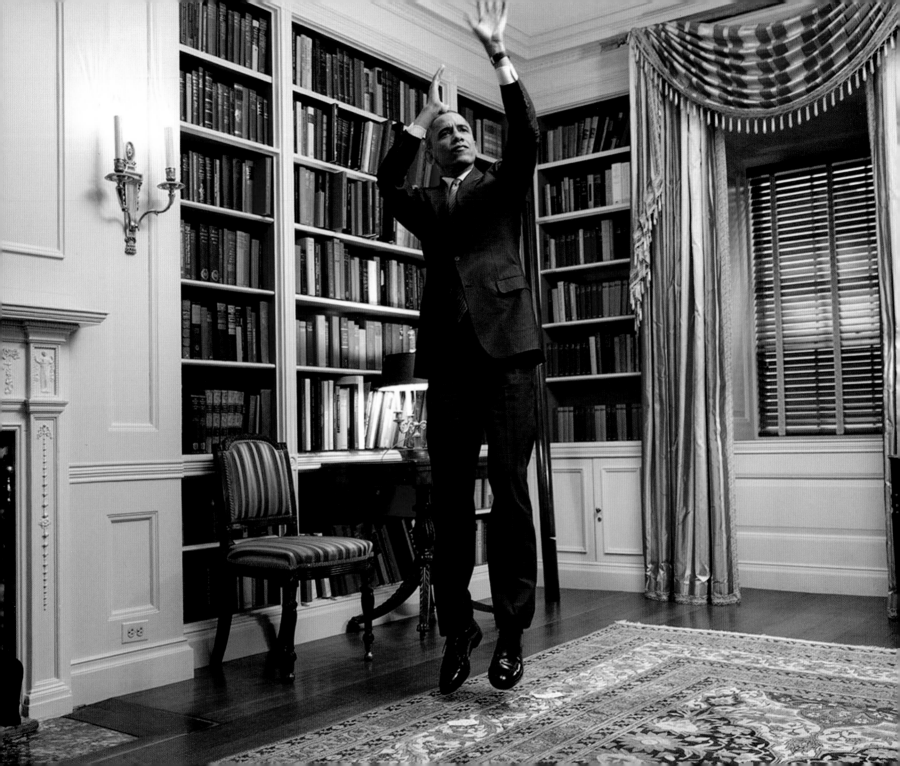

"Some people now suggest that I'm too professorial. And I'd like to address that head-on, by assigning all of you some reading that will help you draw your own conclusions. Others say that I'm arrogant. But I've found a really great self-help tool for this: **MY POLL NUMBERS.**"

—White House Correspondents' Association Dinner, April 30, 2011

> **"When ignorant folks want to advertise their ignorance, you don't really have to do anything, you JUST LET THEM TALK."**

—News Conference in Kuala Lumpur, Malaysia, April 27, 2014

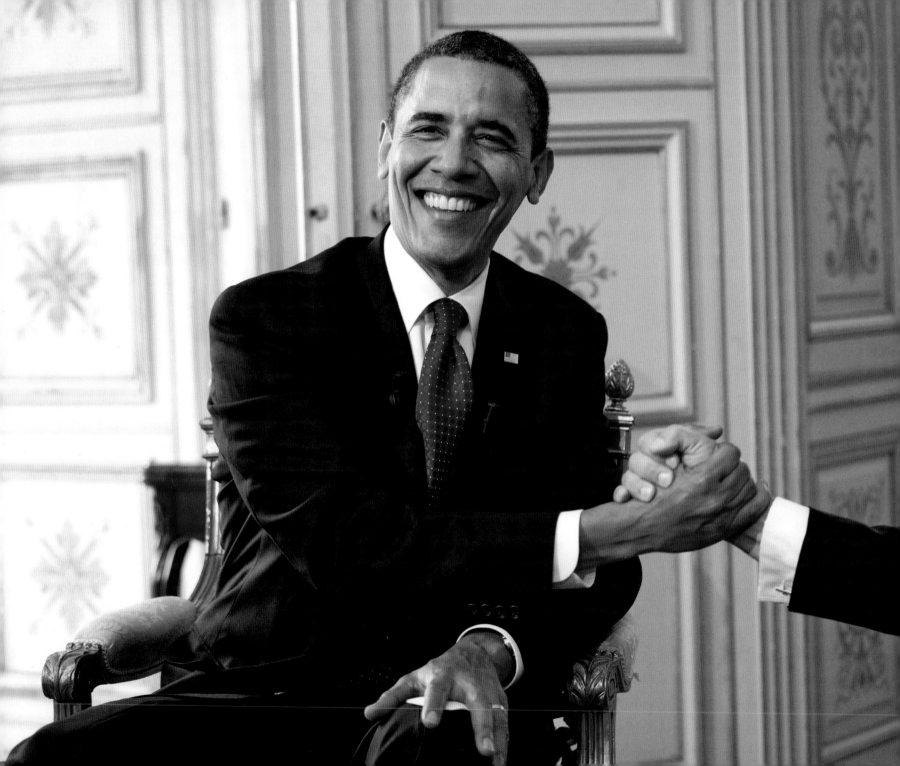

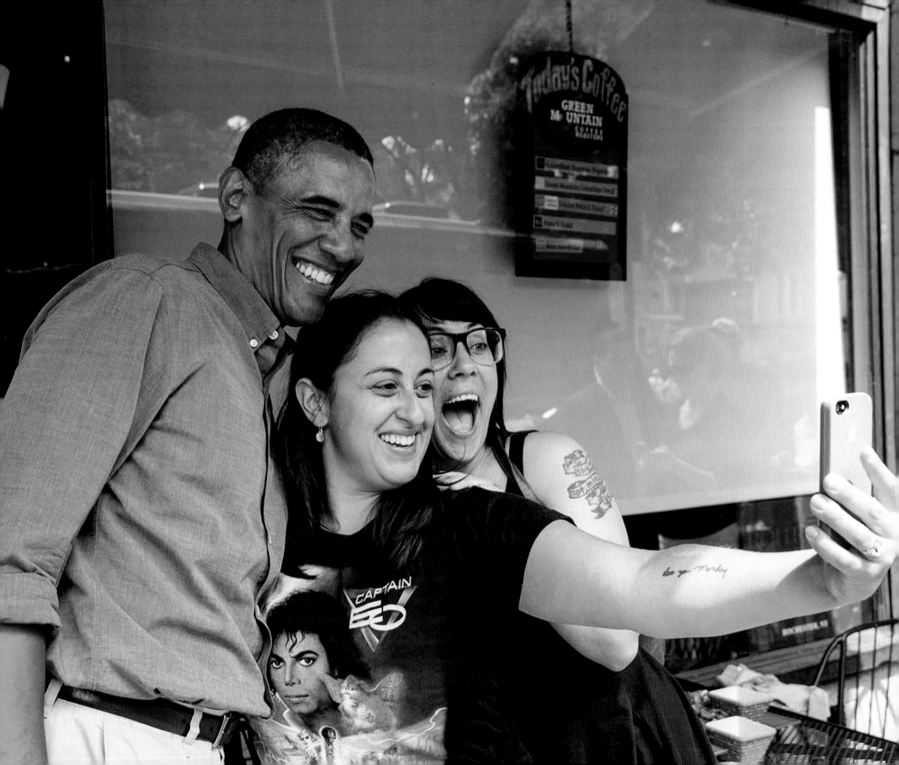

"YOU CANNOT SIT BACK AND WAIT FOR A SAVIOR. You can't opt out because you don't feel sufficiently inspired by this or that particular candidate. This is not a rock concert. **THIS IS NOT COACHELLA."**

—Paul H. Douglas Awards, University of Illinois, September 7, 2018

> "I am determined to make the most of every moment I have left. After the midterm elections, my advisors asked me 'Mr. President, do you have a bucket list?'

AND I SAID, 'WELL, I HAVE SOMETHING THAT RHYMES WITH BUCKET LIST.'

Take executive action on immigration. Bucket. New climate regulations. Bucket. It's the right thing to do."

—White House Correspondents' Association Dinner, April 25, 2015

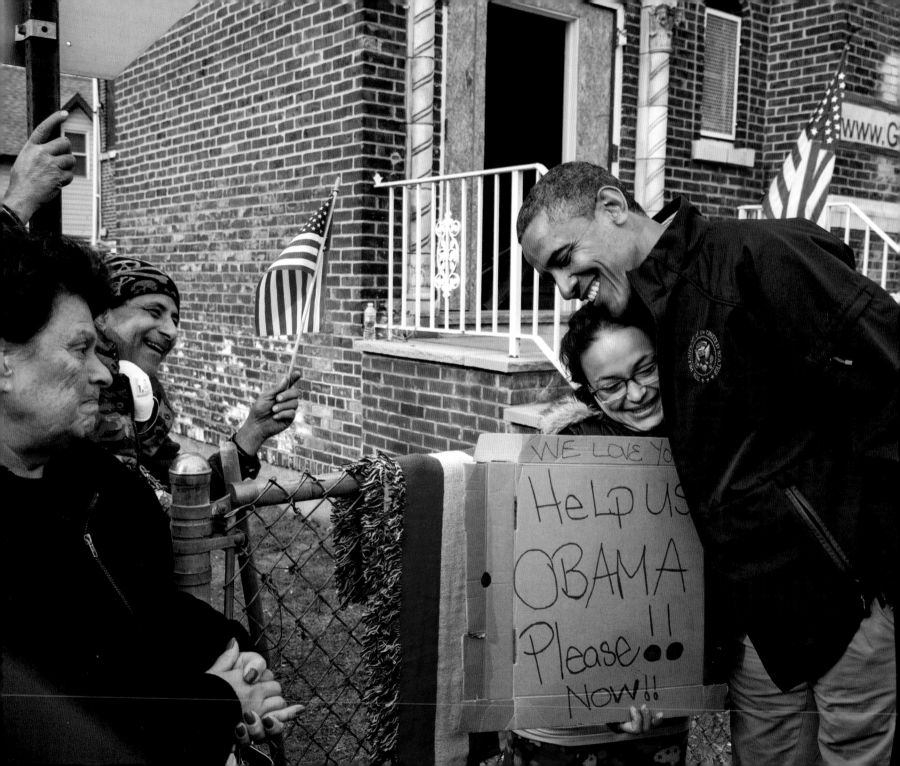

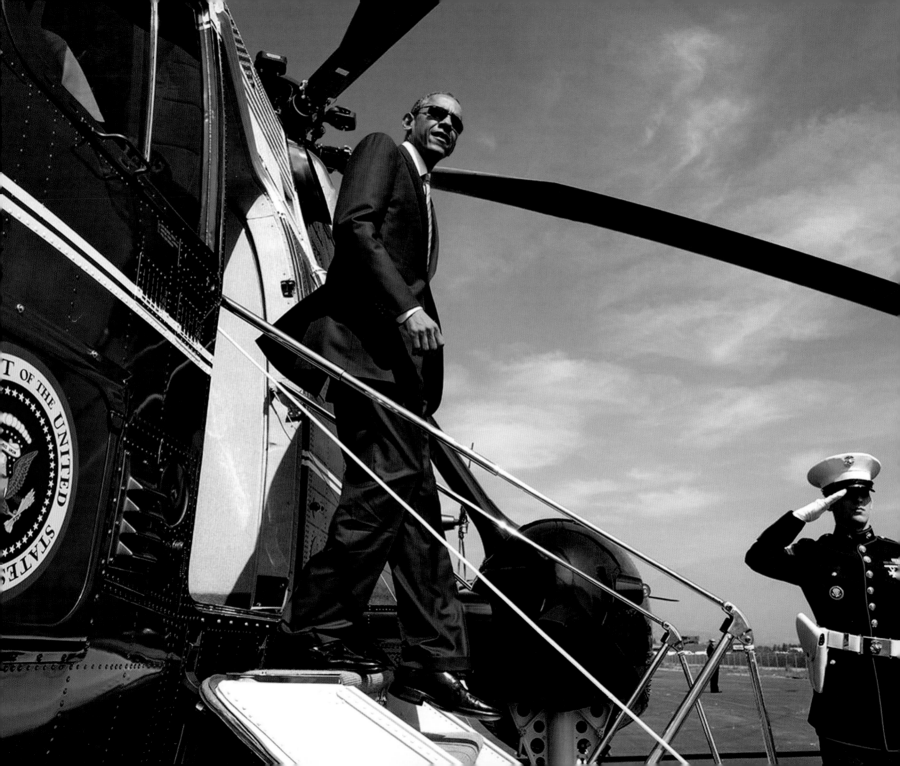

> " I even sat for an interview with Bill O'Reilly right before the Super Bowl.

THAT WAS A CHANGE OF PACE.

I don't often get a chance to be in a room with an ego that's bigger than mine. "

—Gridiron Club and Foundation Dinner, March 12, 2011

> "Somehow, despite all this, despite the churn, in my final year, my approval ratings keep going up.

THE LAST TIME I WAS THIS HIGH,

I was trying to decide on my major."

—White House Correspondents' Association Dinner, April 30, 2016

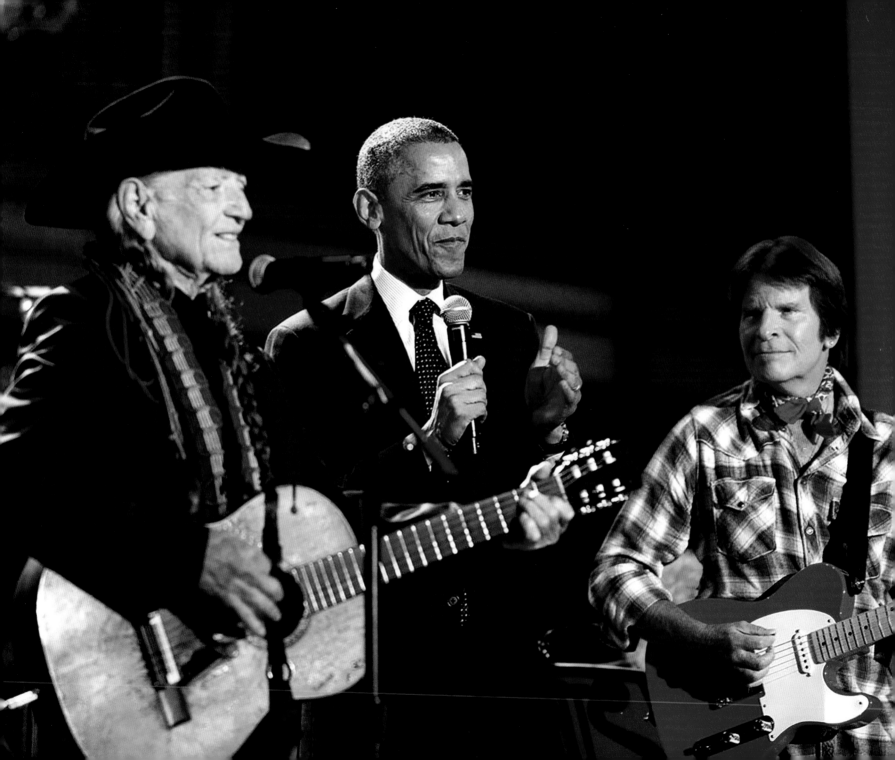

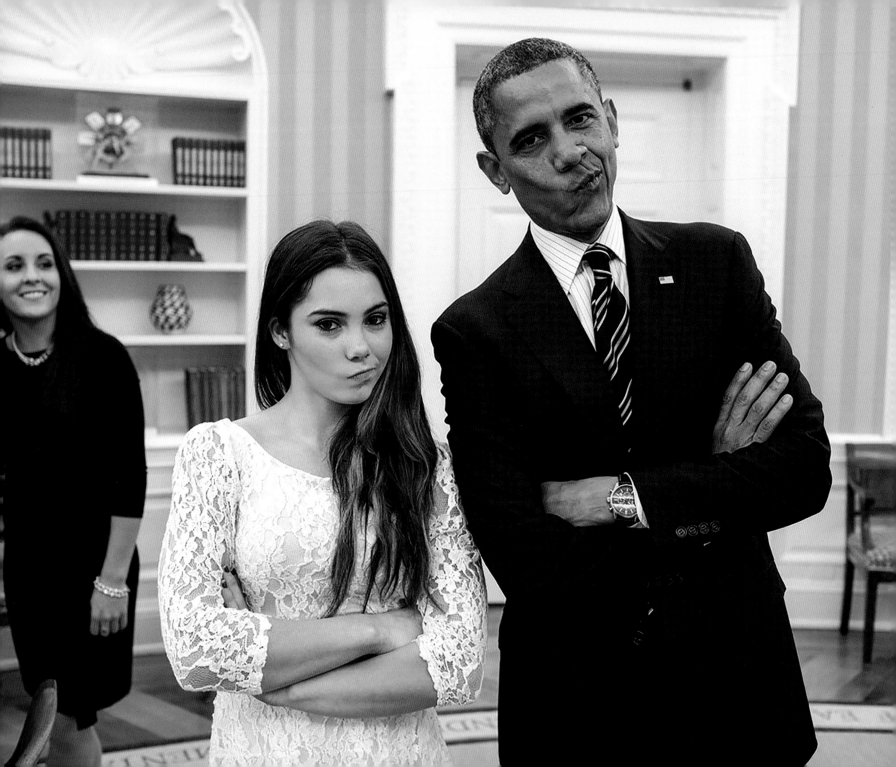

"It is true I have not managed to make everybody happy. Six years into my presidency **SOME PEOPLE STILL SAY I'M ARROGANT,** aloof, condescending. Some people are so dumb. **NO WONDER I DON'T MEET WITH THEM."**

—White House Correspondents' Association Dinner, April 25, 2015

"My charm offensive has helped me learn some interesting things about what's going on in Congress—

IT TURNS OUT, ABSOLUTELY NOTHING."

—White House Correspondents' Association Dinner, April 27, 2013

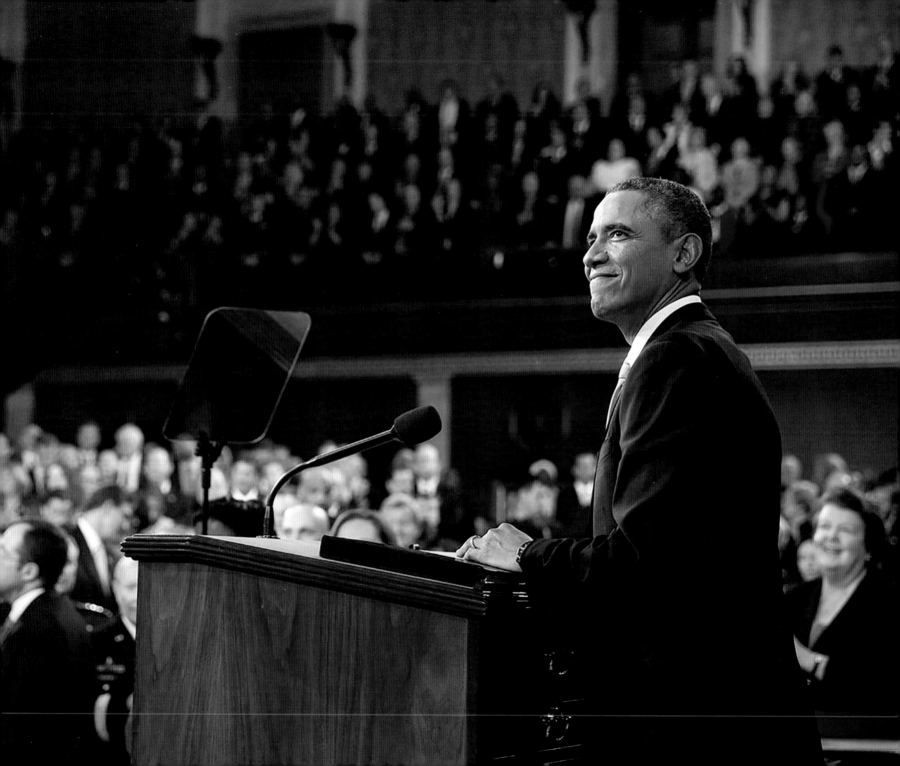

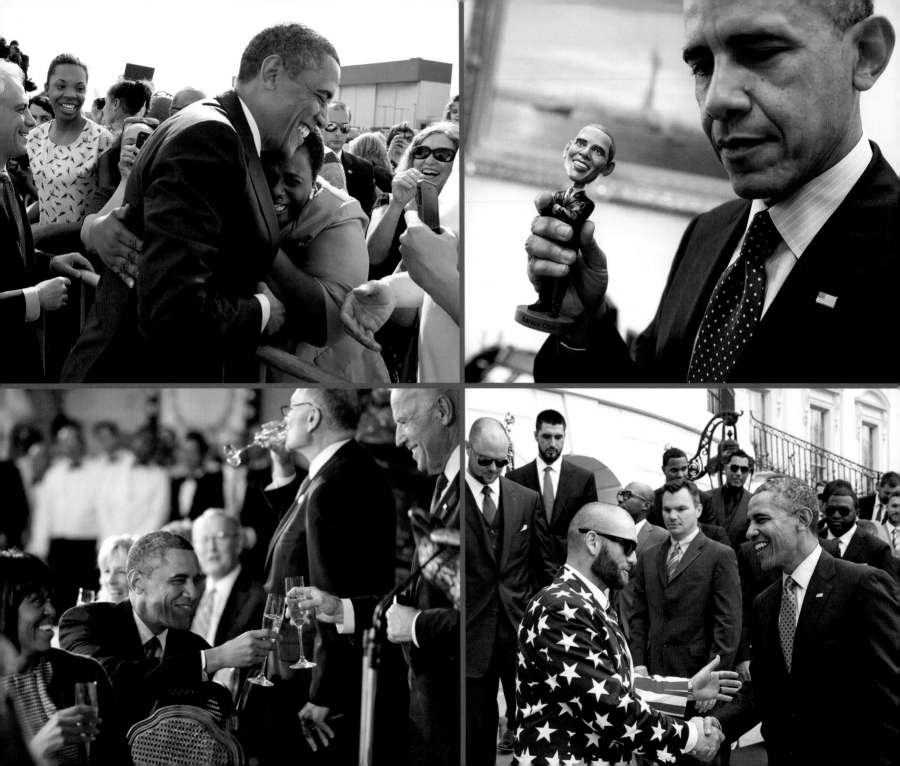

ACROSS
THE AISLE

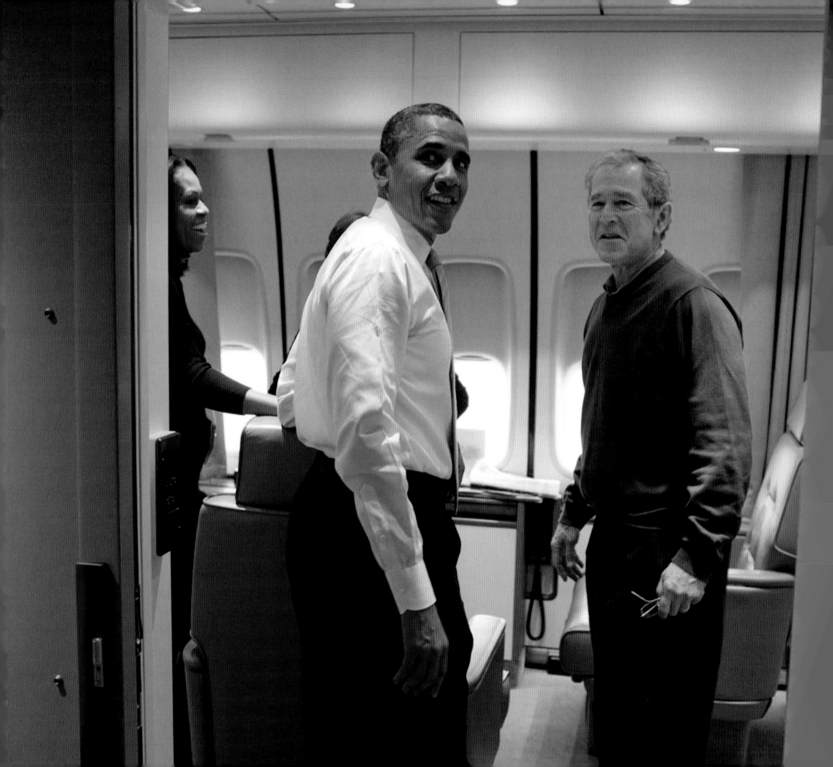

> "Now, some have said I blame too many problems on my predecessor, **BUT LET'S NOT FORGET** that's a practice that was initiated by George W. Bush."

—White House Correspondents' Association Dinner, April 28, 2012

"Just this week, Michele Bachmann predicted I would bring about the biblical end of days. **NOW *THAT'S* A LEGACY.** That's big. I mean, Lincoln, Washington, they didn't do that."

—White House Correspondents' Association Dinner, April 25, 2015

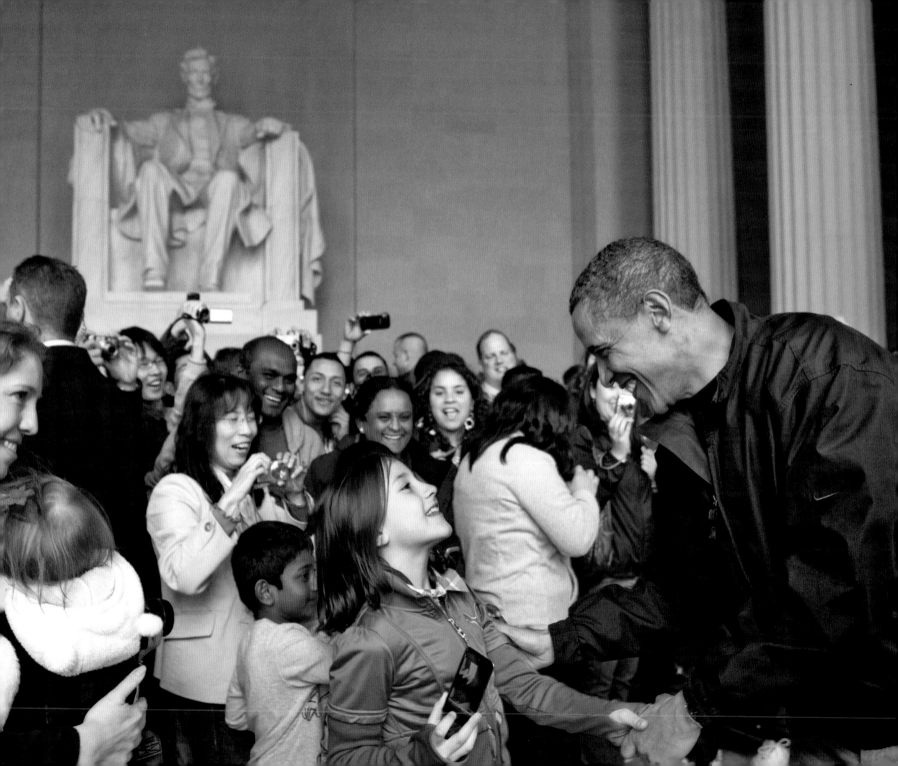

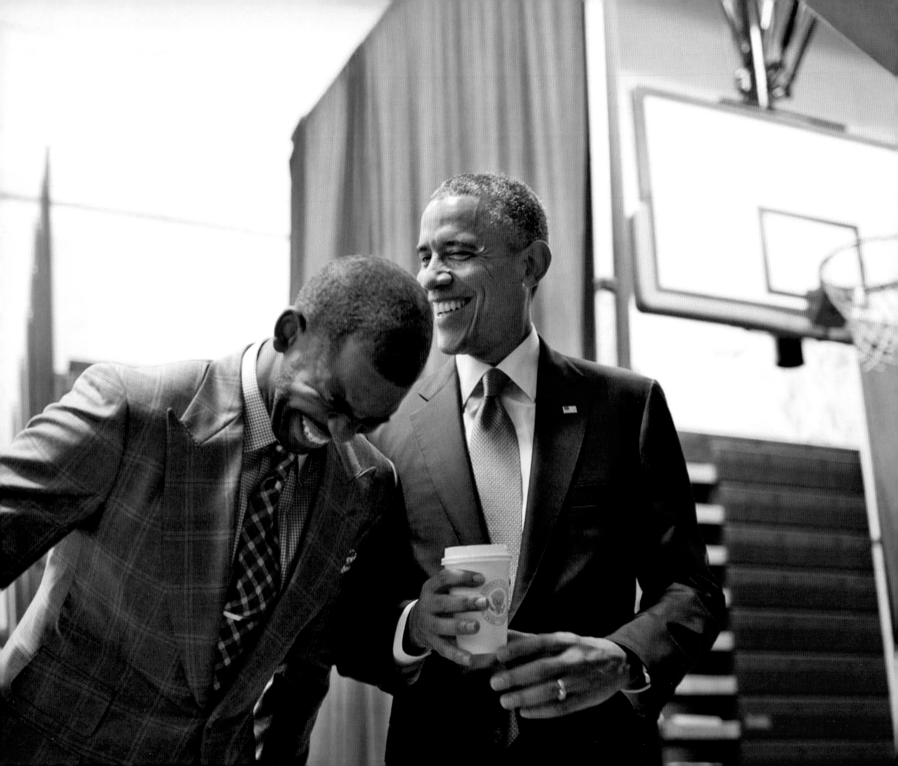

"TED CRUZ HAD A TOUGH WEEK.
He went to Indiana—Hoosier country—
stood on a basketball court, and
**CALLED THE HOOP A
'BASKETBALL RING.'**
What else is in his lexicon?
Baseball sticks? Football hats?
But sure, I'm the foreign one."

—White House Correspondents' Association Dinner, April 30, 2016

> "Dick Cheney says he thinks I'm the worst president of his lifetime. Which is interesting because I think Dick Cheney is the **WORST PRESIDENT OF MY LIFETIME.**"

—White House Correspondents' Association Dinner, April 25, 2015

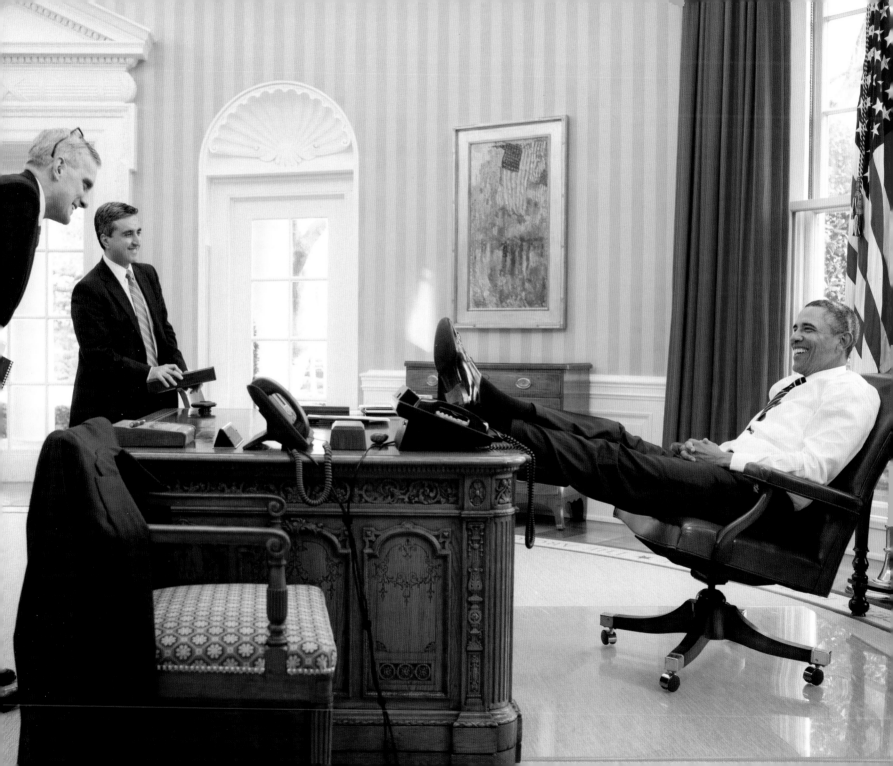

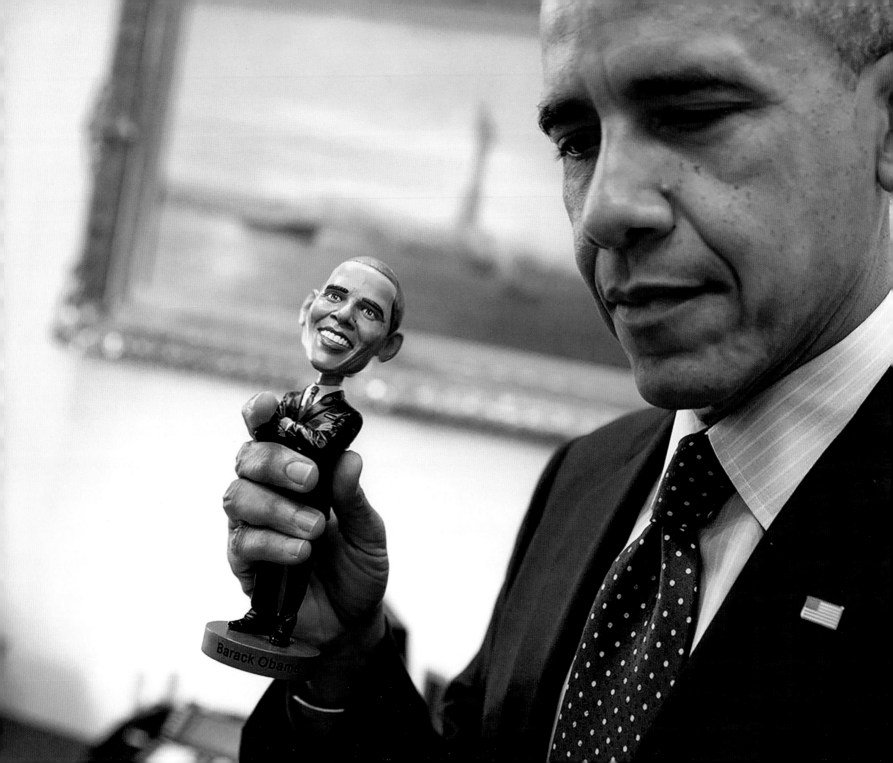

> "I know Republicans are still sorting out what happened in 2012, but one thing they all agree on is they need to do a better job reaching out to minorities. And look, call me self-centered, but

I CAN THINK OF ONE MINORITY THEY COULD START WITH.

Hello? Think of me as a trial run, you know? See how it goes."

—White House Correspondents' Association Dinner, April 27, 2013

"The Koch brothers think they need to **SPEND A BILLION DOLLARS TO GET FOLKS TO LIKE ONE OF THESE PEOPLE.** It's got to hurt their feelings a little bit. And, look, I know I've raised a lot of money too, but in all fairness, my middle name is Hussein. What's their excuse?"

—White House Correspondents' Association Dinner, April 25, 2015

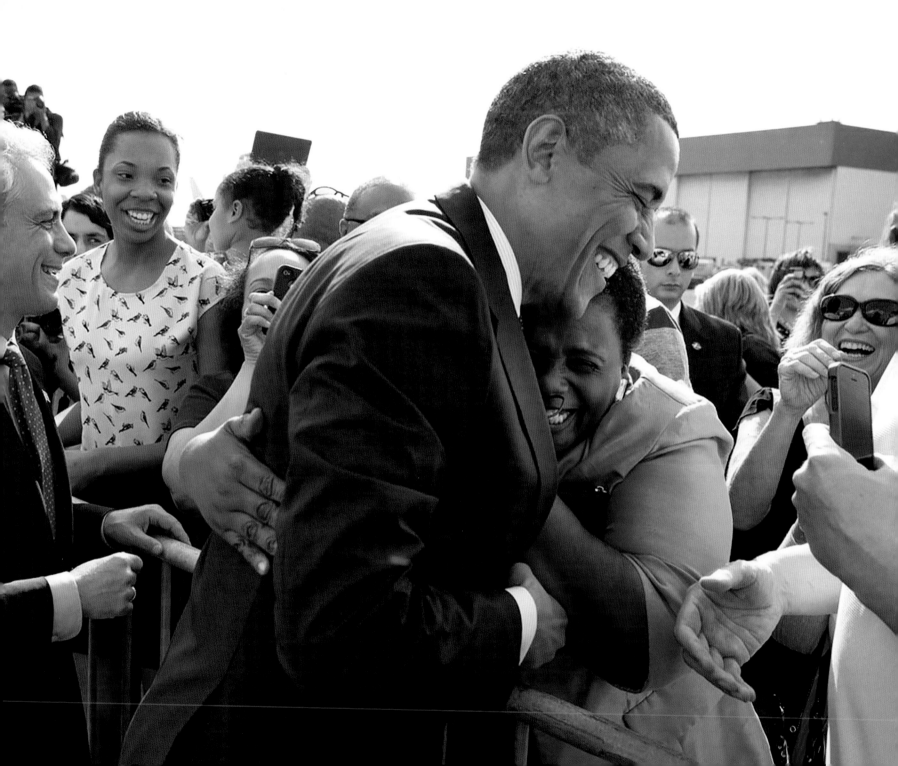

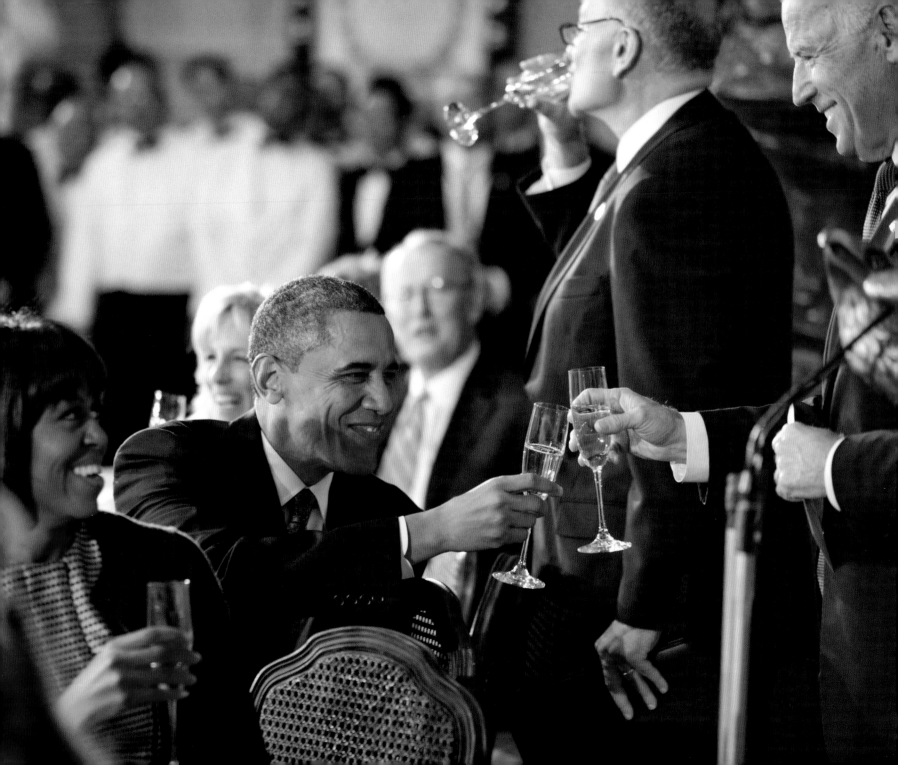

> "I had dinner with a number of the Republican senators. And I'll admit it wasn't easy. **I PROPOSED A TOAST— IT DIED IN COMMITTEE.**"

—White House Correspondents' Association Dinner, April 27, 2013

" I am a little hurt that he's not here tonight. We had so much fun the last time. And it is surprising. **YOU'VE GOT A ROOM FULL OF REPORTERS,** celebrities, cameras, and he says no? Is this dinner **TOO TACKY FOR THE DONALD?** What could he possibly be doing instead? Is he at home, **EATING A TRUMP STEAK—TWEETING** out insults to Angela Merkel? "

—White House Correspondents' Association Dinner, April 30, 2016

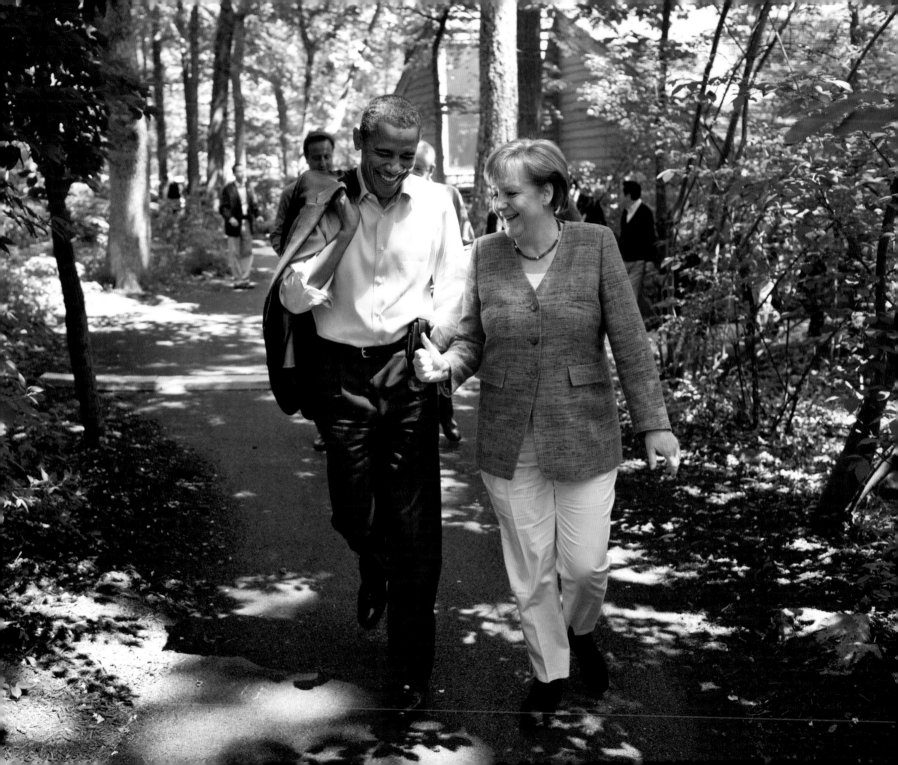

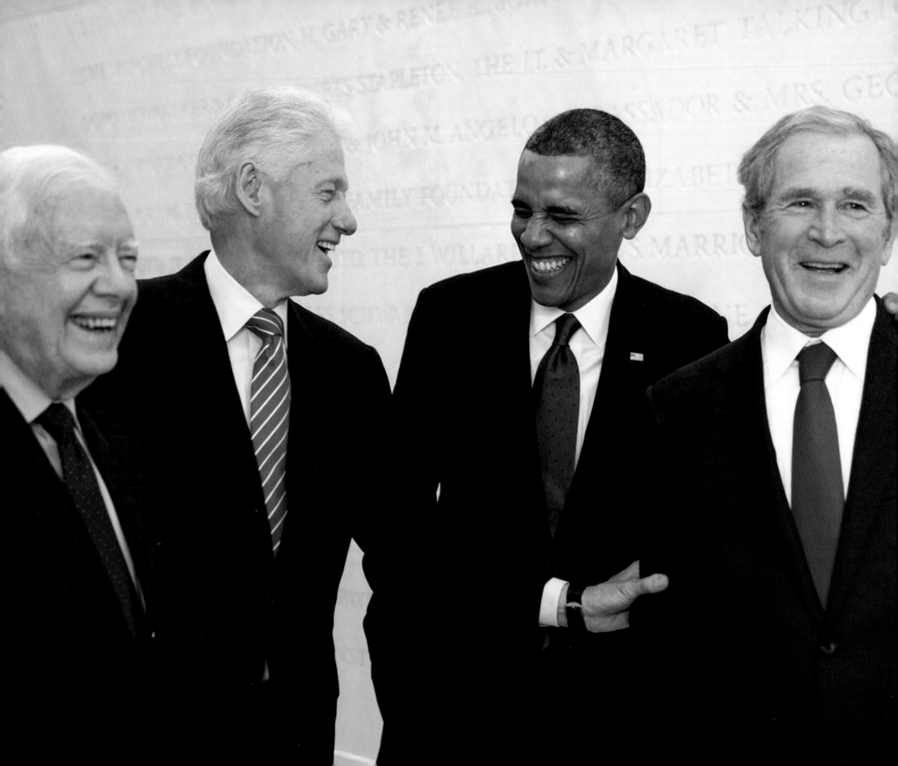

"And there's one area where **DONALD'S EXPERIENCE** could be invaluable—and that's closing Guantanamo. Because Trump knows a thing or two about running waterfront properties into the ground."

—White House Correspondents' Association Dinner, April 30, 2016

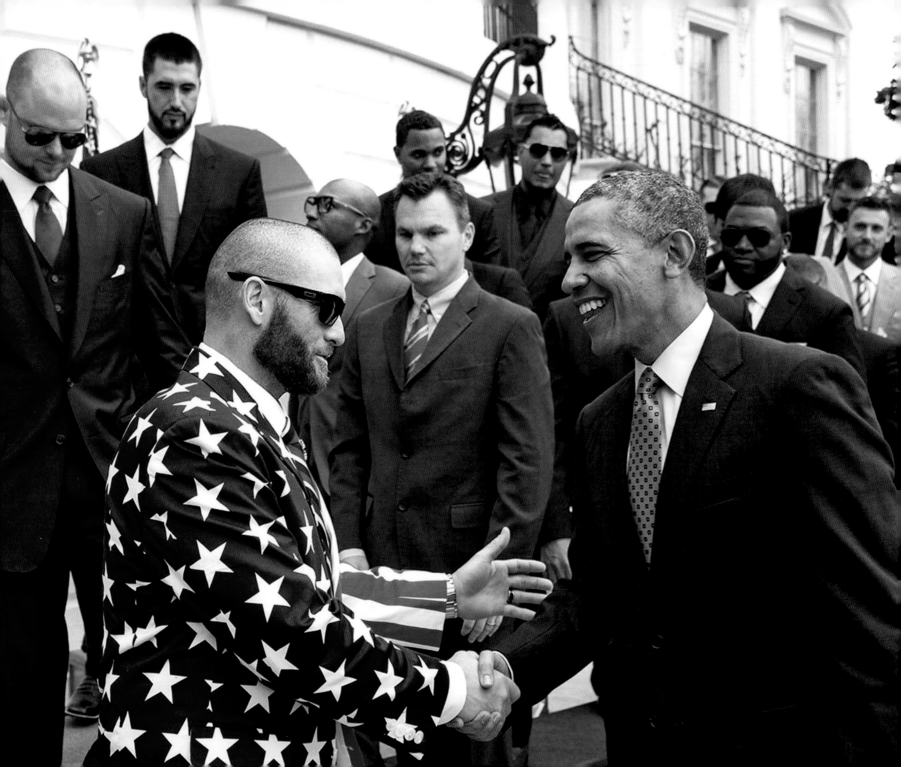

"**CONGRESS** and I have certainly had our differences; yet, I've tried to be civil, to not take any cheap shots. And that's why I want to especially thank all the members who **TOOK A BREAK FROM THEIR EXHAUSTING SCHEDULE** of not passing any laws to be here tonight."

—White House Correspondents' Association Dinner, April 28, 2012

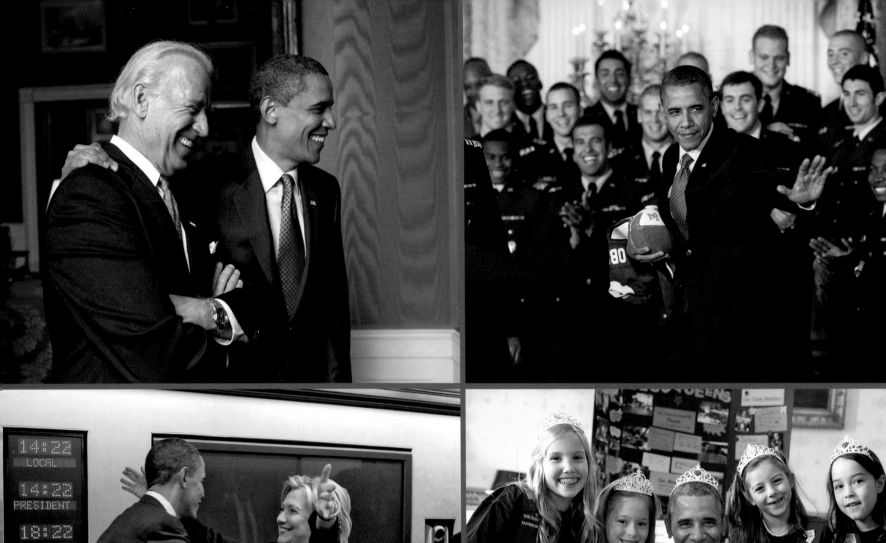
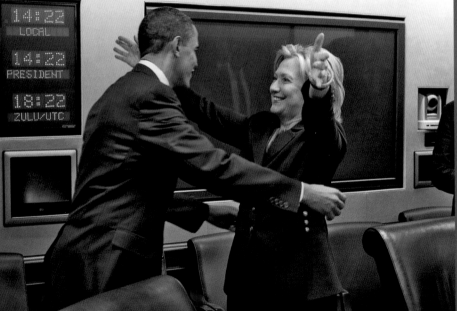
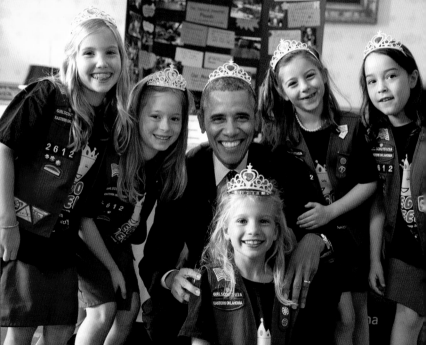

FRIENDS

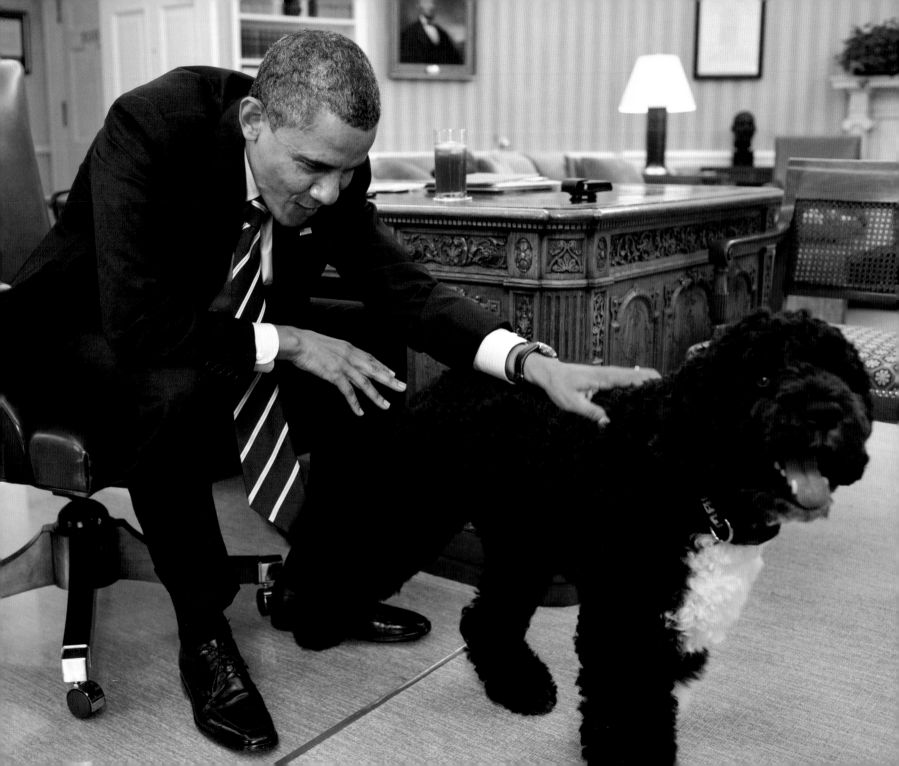

" He's warm, he's cuddly, loyal, enthusiastic; **YOU JUST HAVE TO KEEP HIM ON A TIGHT LEASH—** every once in a while he goes charging off and gets himself into trouble. **ENOUGH ABOUT JOE BIDEN.** "

—White House Correspondents' Association Dinner, May 9, 2009

"Prince George showed up to our meeting **IN HIS BATHROBE.** That was a slap in the face."

—White House Correspondents' Association Dinner, April 30, 2016

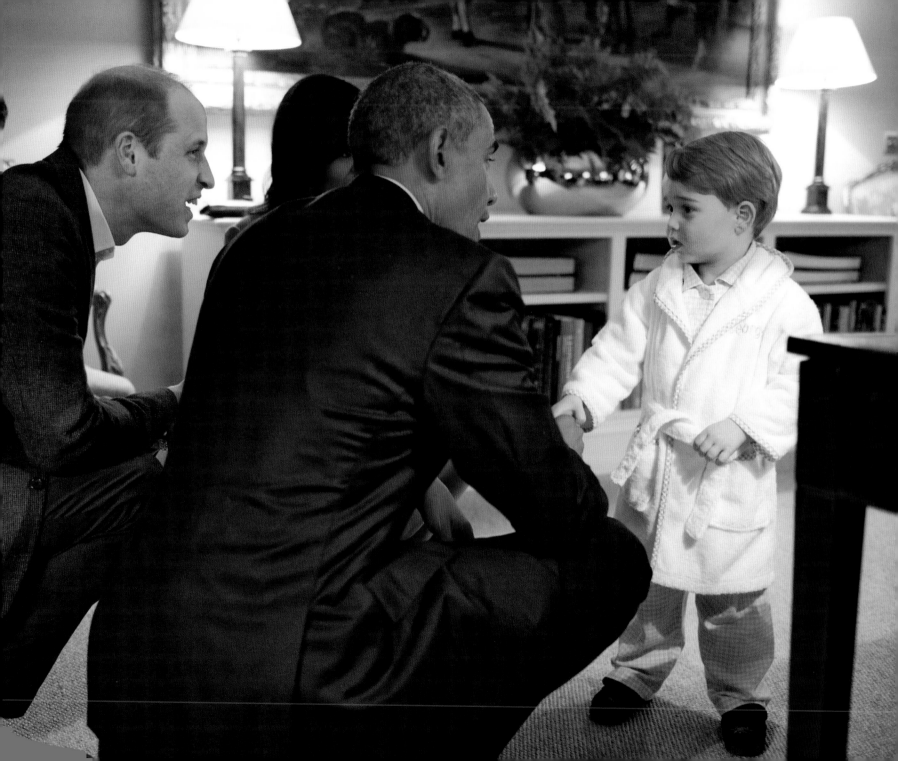

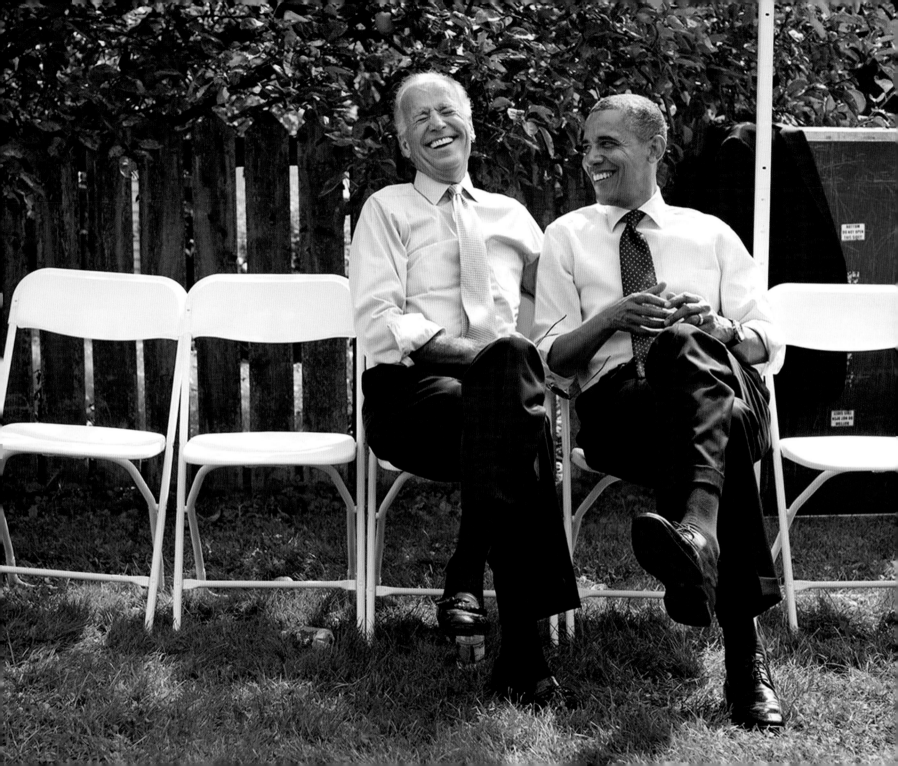

"I tease Joe Biden, but you know he has been at my side for seven years. **I LOVE THAT MAN.** He's not just a great vice president, he is a great friend. We've gotten so close, in some places in Indiana, they won't serve us pizza anymore."

—White House Correspondents' Association Dinner, April 25, 2015

"I had a lot more material prepared, **BUT I HAVE TO GET THE SECRET SERVICE HOME IN TIME FOR THEIR NEW CURFEW.**"

—White House Correspondents' Association Dinner, April 28, 2012

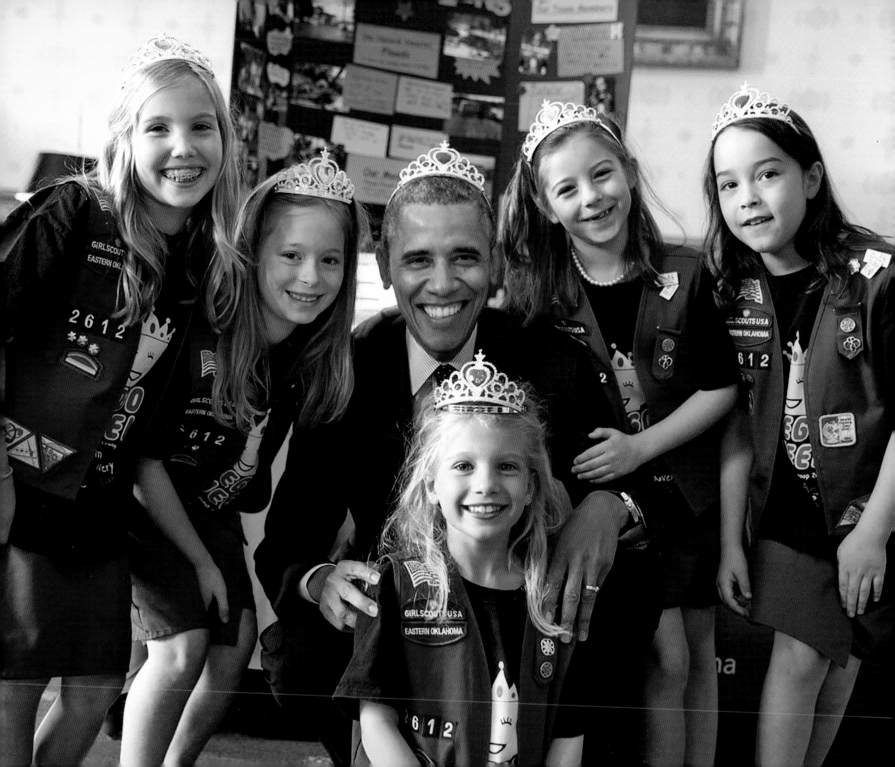

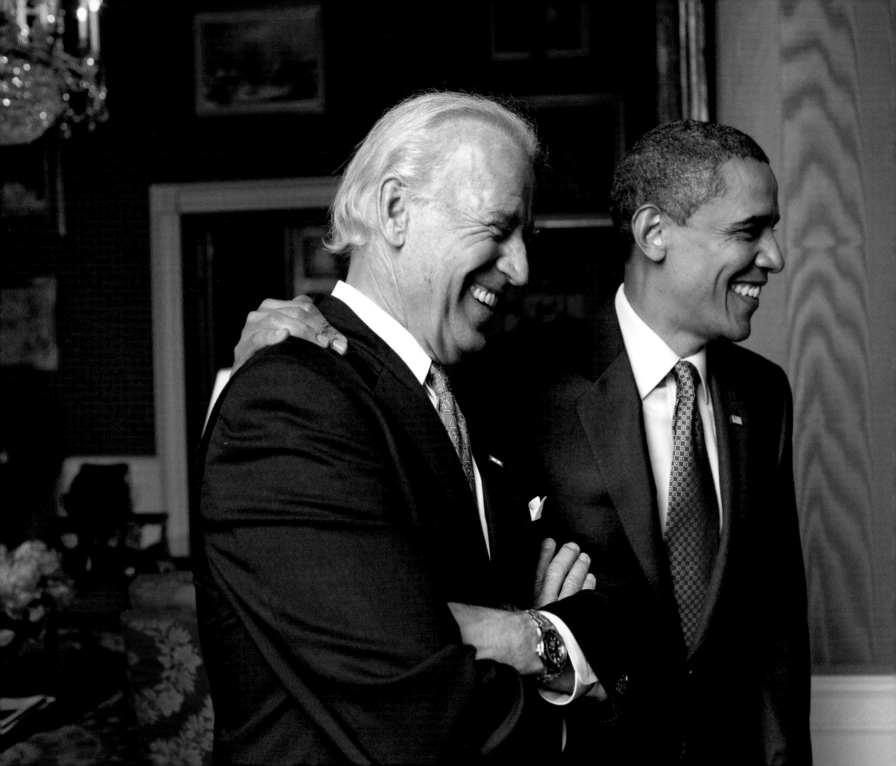

> **ME:** Joe, about halfway through the speech, I'm gonna wish you a happy birth—
>
> **BIDEN:** IT'S MY BIRTHDAY!
>
> **ME:** Joe.

—@BarackObama Twitter, November 20, 2017

"Four years ago, I was locked in a brutal primary battle with **HILLARY CLINTON.** Four years later, she won't stop **DRUNK-TEXTING ME FROM CARTAGENA.**"

—White House Correspondents' Association Dinner, April 28, 2012

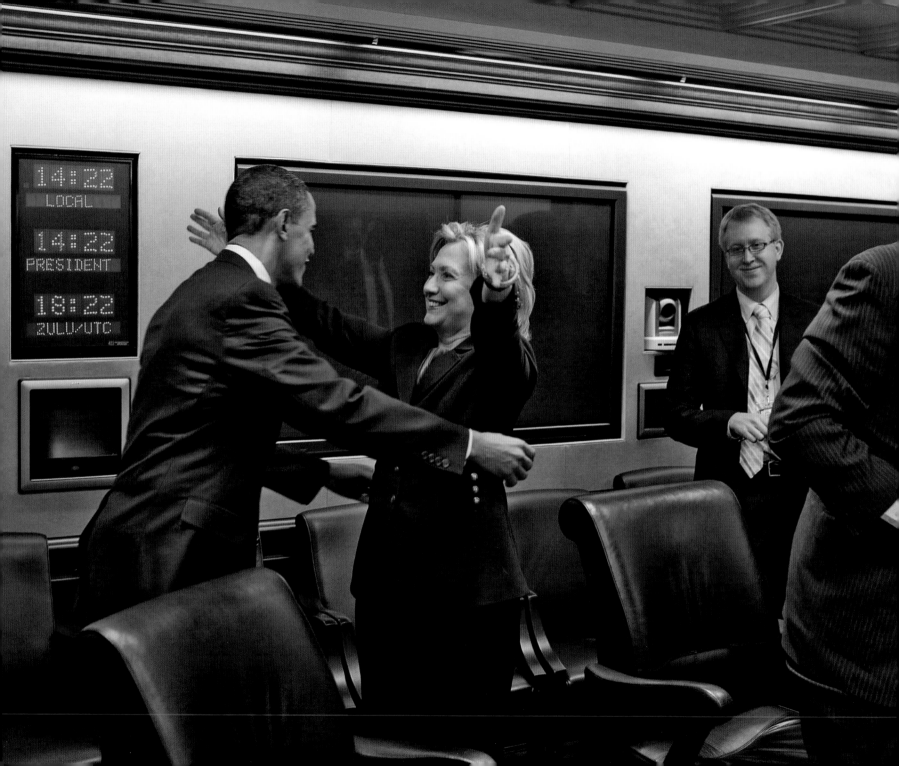

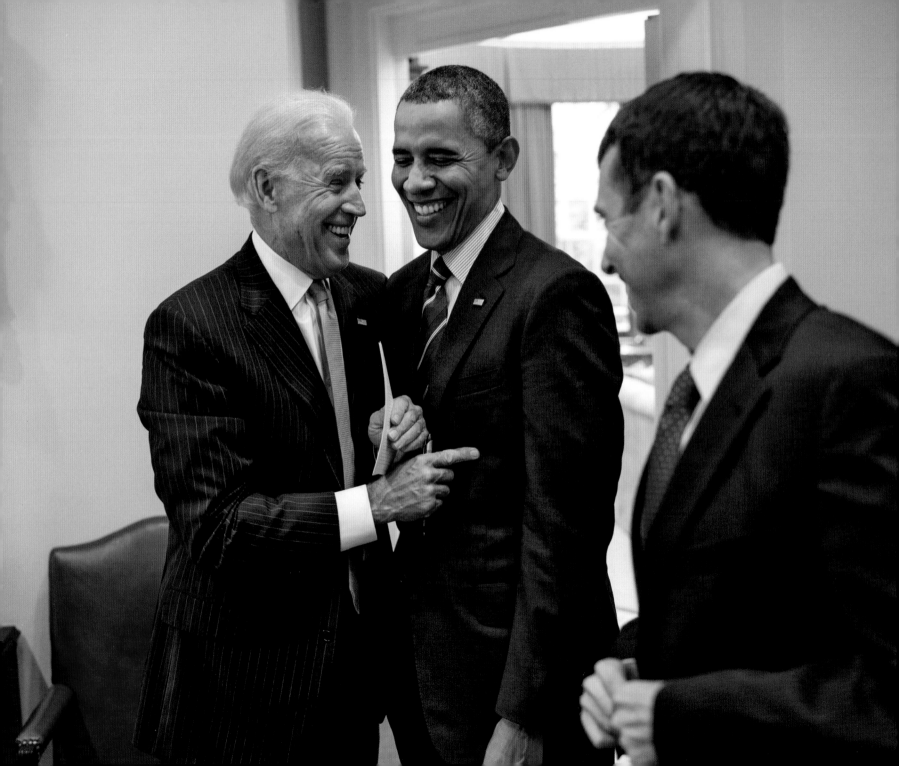

" I wasn't sure that I should actually come tonight. **BIDEN TALKED ME INTO IT.** He leaned over and he said, 'Mr. President, this is no ordinary dinner. This is a **BIG** ****ing meal.' "

—White House Correspondents' Association Dinner, May 10, 2010

"I do really well with the zero-to-eight demographic. **YEAH, THEY LOVE ME.** Partly 'cause I think **MY EARS ARE BIG,** and so, I look a little **LIKE A CARTOON CHARACTER,** and then little kids love saying my name. But it's all one big name. It's **'BARACKOBAMA.'**"

—*Comedians in Cars Getting Coffee*, Season 7, Episode 1

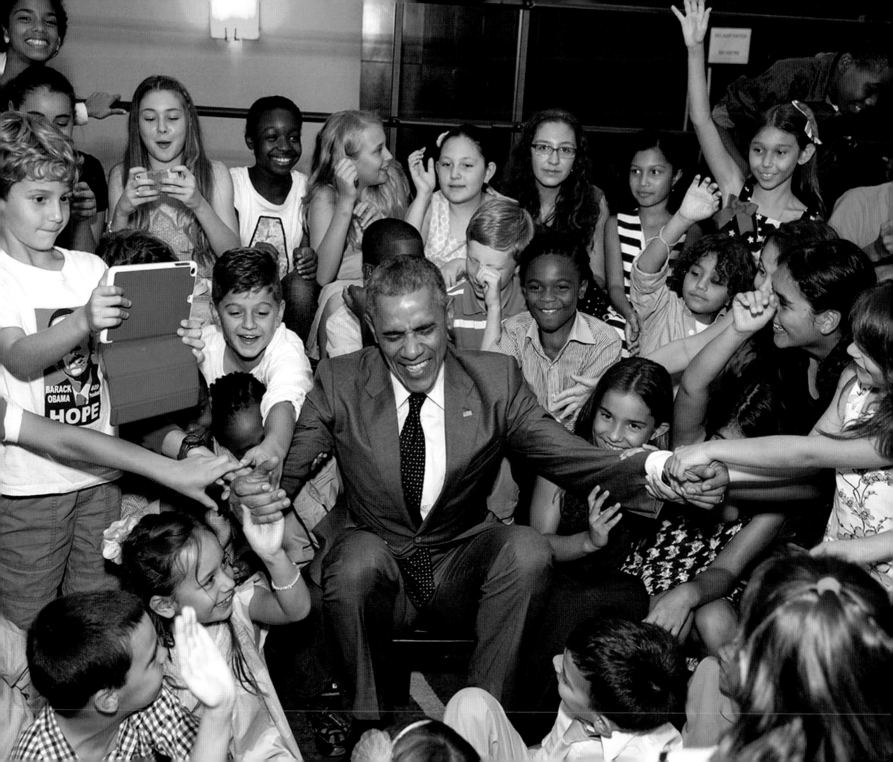

"Somebody recently said to me, Mr. President, you are so yesterday; **JUSTIN TRUDEAU** has completely replaced you—he's so **HANDSOME**, he's so **CHARMING**, he's **THE FUTURE**. And I said, Justin, **JUST GIVE IT A REST.**"

—White House Correspondents' Association Dinner, April 30, 2016

"The fact is, I feel more loose and relaxed than ever. Those Joe Biden shoulder massages— **THEY'RE LIKE MAGIC.** You should try one. **OH, YOU HAVE.**"

—White House Correspondents' Association Dinner, April 25, 2015

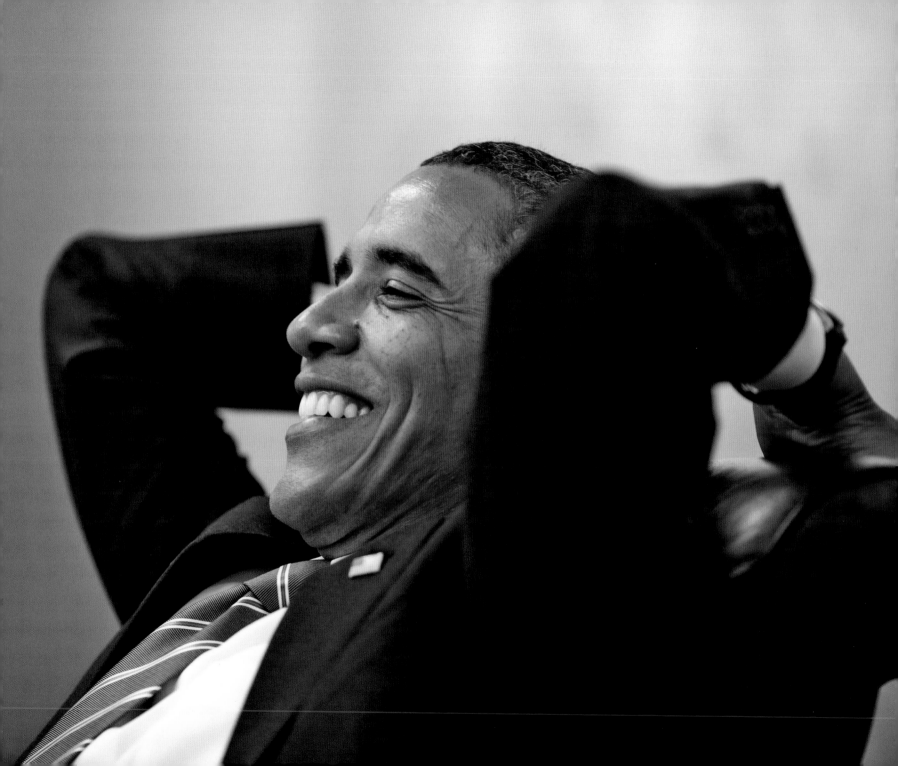

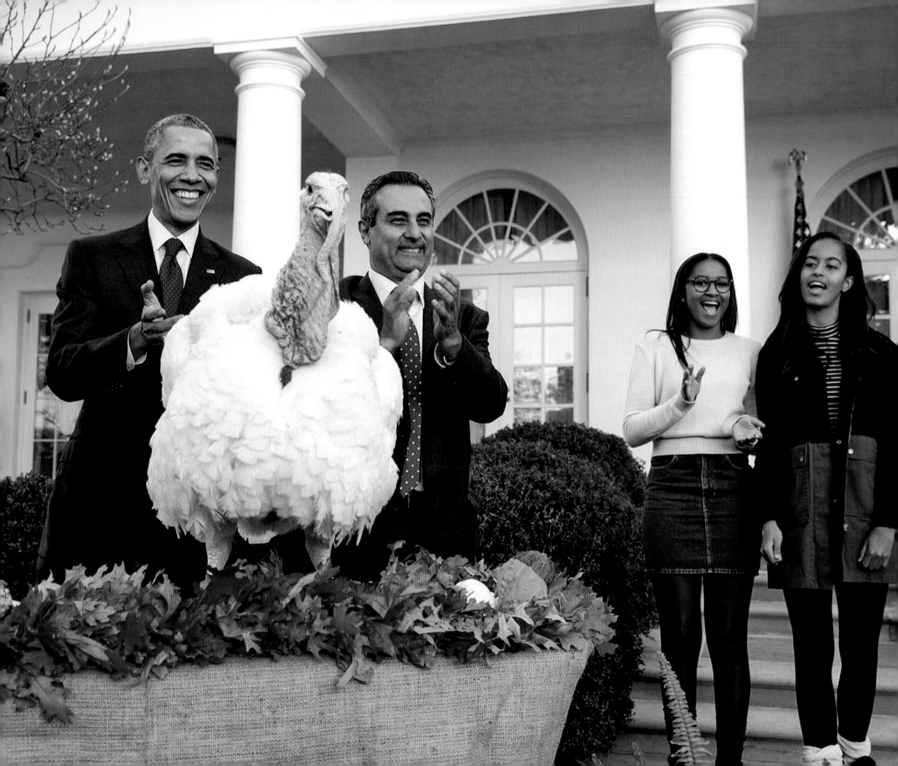

"I want to take a moment to recognize **THE BRAVE TURKEYS** who weren't so lucky, who didn't get to ride the **GRAVY TRAIN TO FREEDOM**, who met their fate with courage and sacrifice and proved that **THEY WEREN'T CHICKEN.**"

—Thanksgiving Turkey Pardon, November 23, 2016

> "Hillary trying to appeal to young voters is a little bit like your relative just signed up for Facebook.

> **'DEAR AMERICA, DID YOU GET MY POKE?** Is it appearing on your wall? I'm not sure I am using this right. **LOVE, AUNT HILLARY.'**"

—White House Correspondents' Association Dinner, April 30, 2016

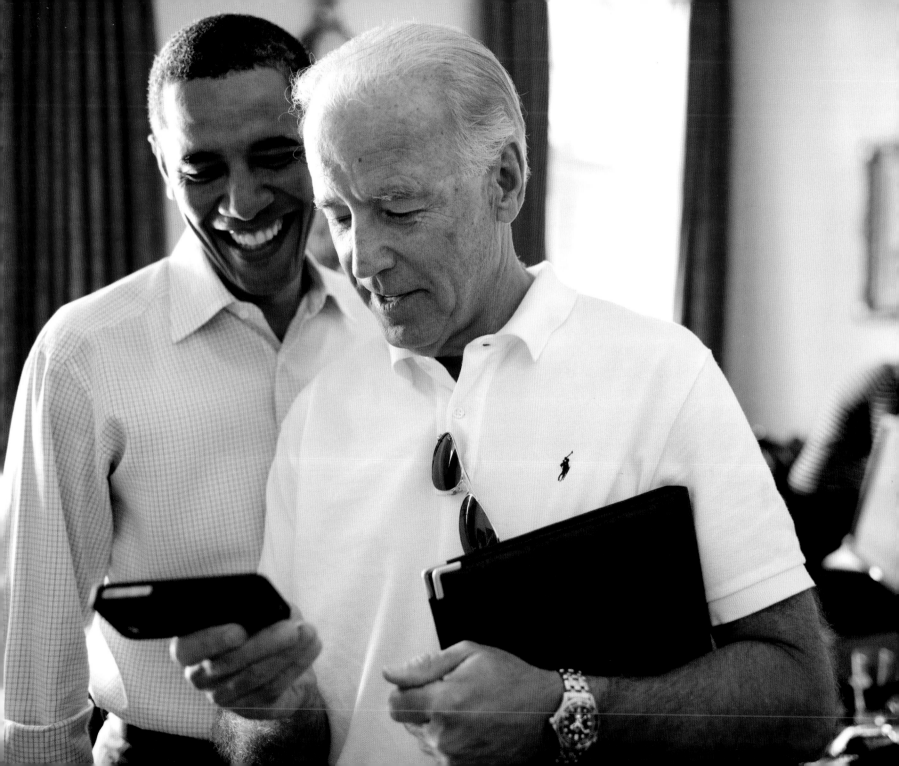

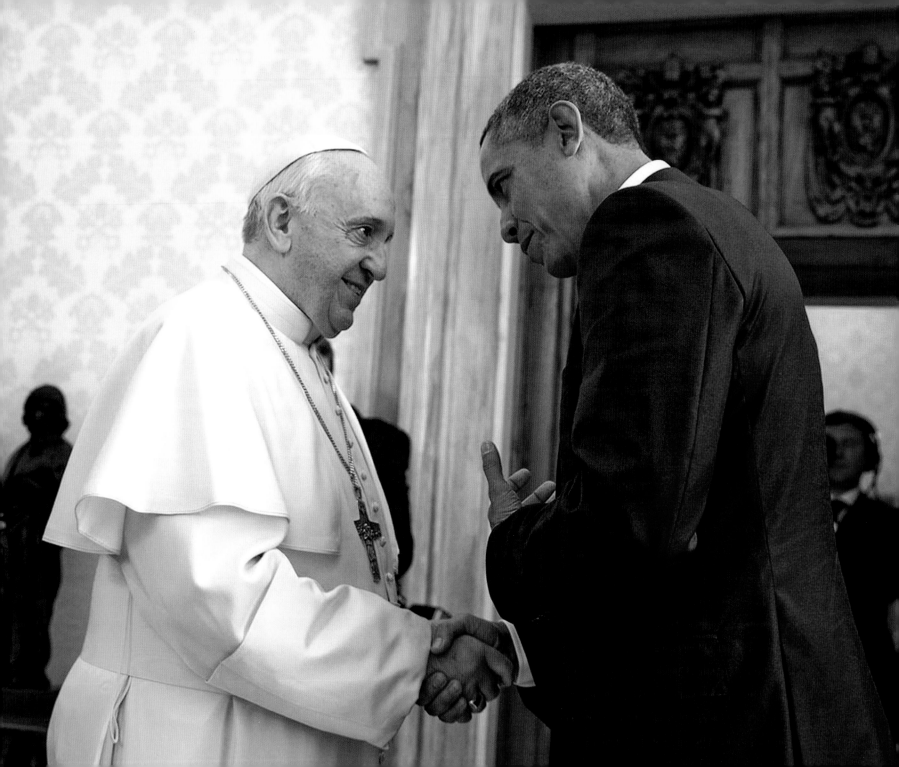

"I have known **FEW GREATER HONORS** than the opportunity to address the Mother of Parliaments at Westminster Hall. I am told that the last three speakers here have been **THE POPE, HER MAJESTY** the Queen, and **NELSON MANDELA**—which is either **A VERY HIGH BAR OR** the beginning of **A VERY FUNNY JOKE.**"

—Westminster Hall, May 25, 2011

"I LOVE JOE BIDEN, I really do. And I want to thank him **FOR HIS FRIENDSHIP,** for his counsel, for always **GIVING IT TO ME STRAIGHT,** for not shooting anybody in the face."

—White House Correspondents' Association Dinner, April 30, 2016

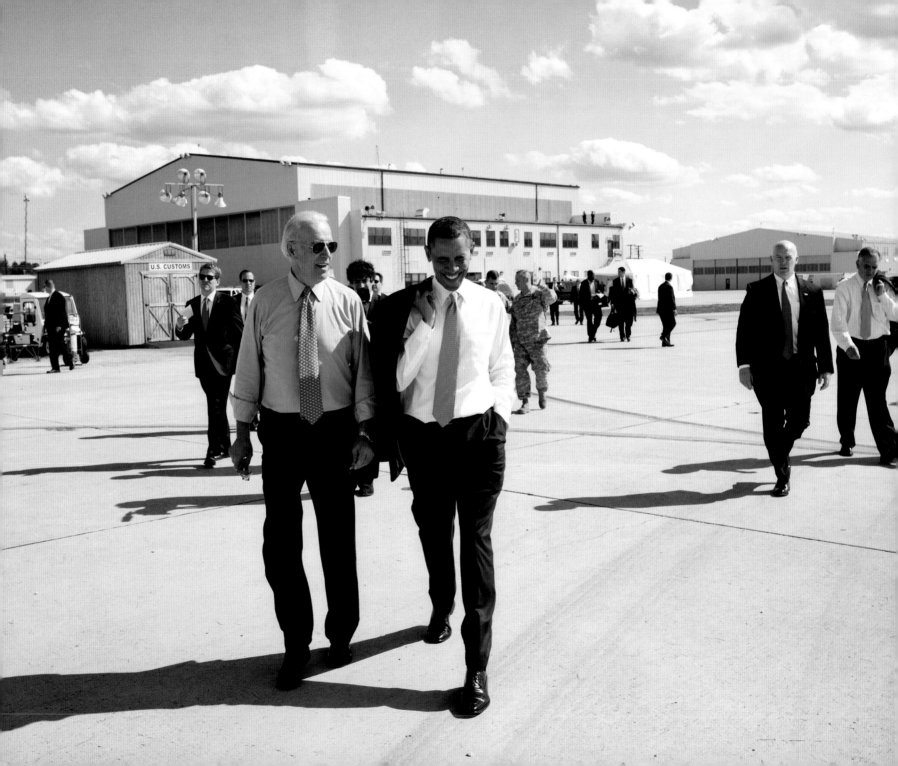

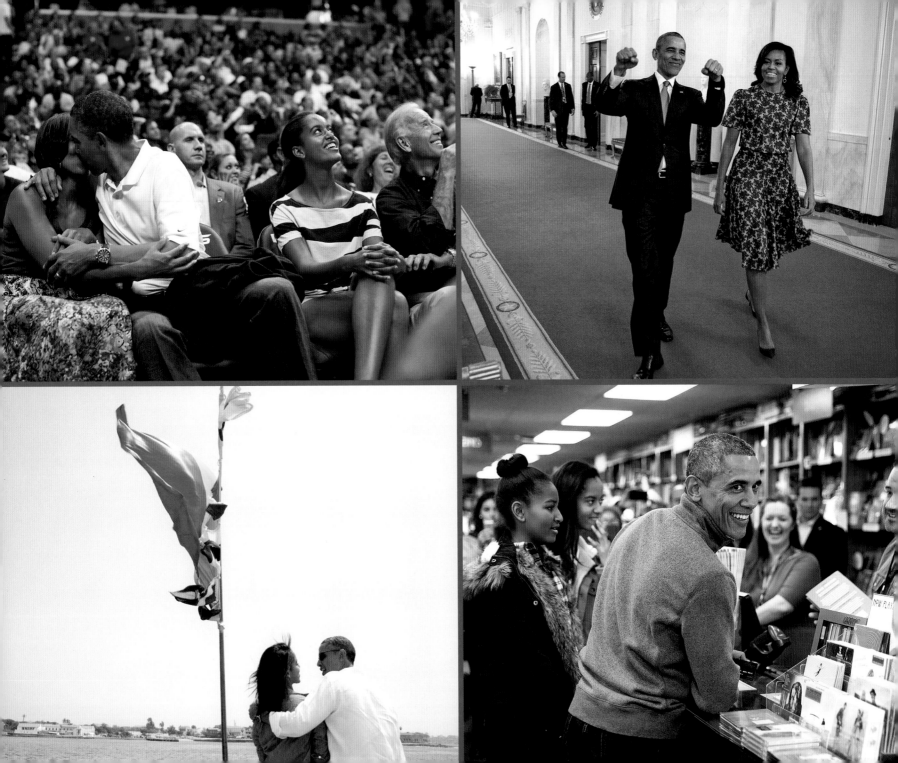

FAMILY

> "Many of you know that **I GOT MY NAME,** Barack, from my father. What you may not know is Barack is actually Swahili for 'That One.' And I got my middle name **FROM SOMEBODY WHO OBVIOUSLY DIDN'T THINK I'D EVER RUN FOR PRESIDENT.**"

—Alfred E. Smith Memorial Dinner, October 16, 2008

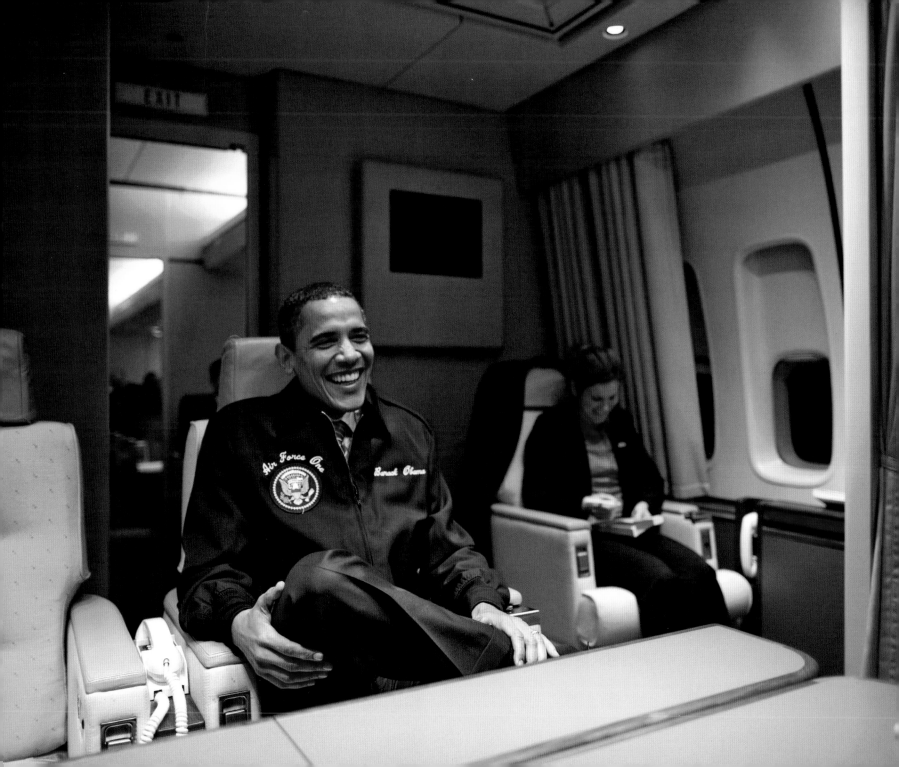

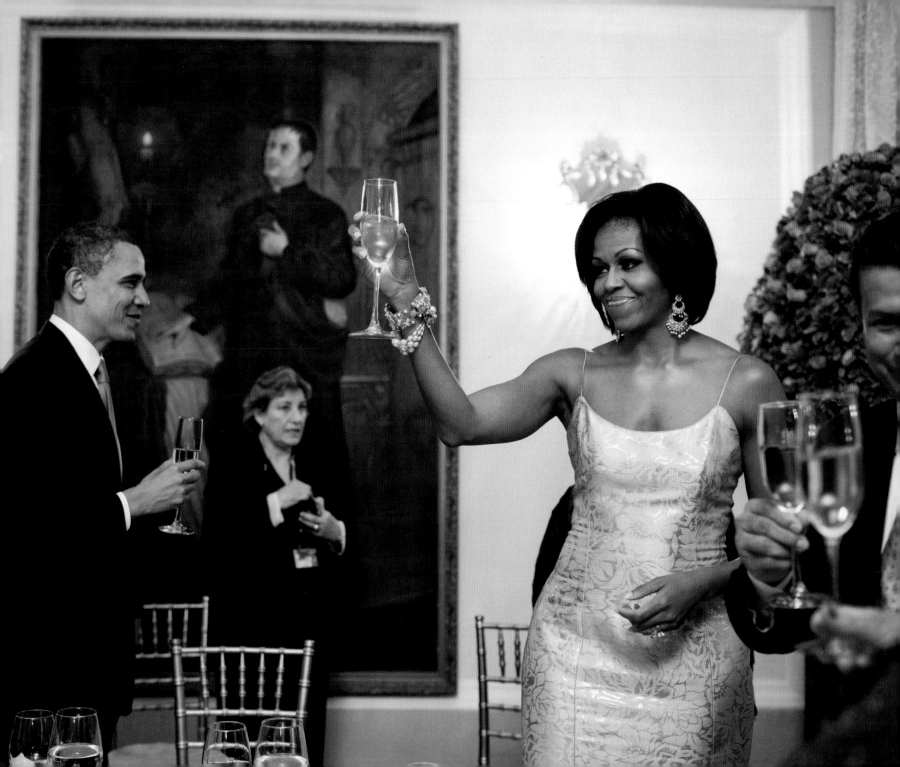

"Hasn't she been an outstanding First Lady? She's even begun to bridge the differences that have divided us for so long, because **NO MATTER WHICH PARTY YOU BELONG TO WE CAN ALL AGREE THAT MICHELLE HAS THE RIGHT TO BARE ARMS.**"

—White House Correspondents' Association Dinner, May 9, 2009

"A lot of folks have been surprised by the **BERNIE PHENOMENON,** especially **HIS APPEAL TO YOUNG PEOPLE.** But not me, **I GET IT.** Just recently, a young person came up to me and said she was sick of politicians standing in the way of her dreams. **AS IF** we were actually going to let Malia go to **BURNING MAN** this year."

—White House Correspondents' Association Dinner, April 30, 2016

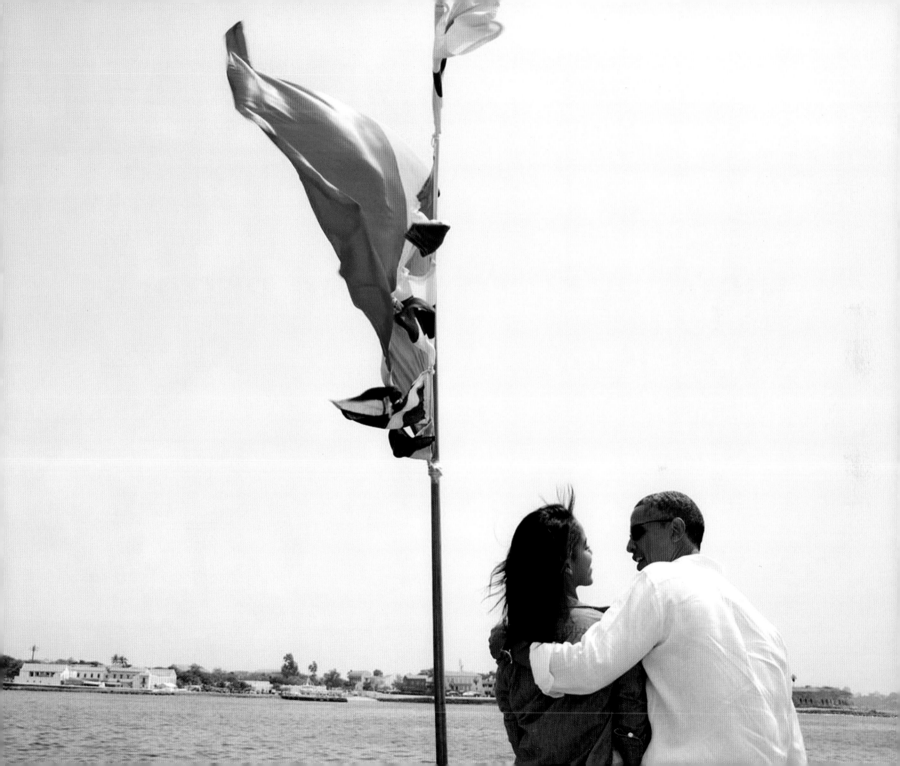

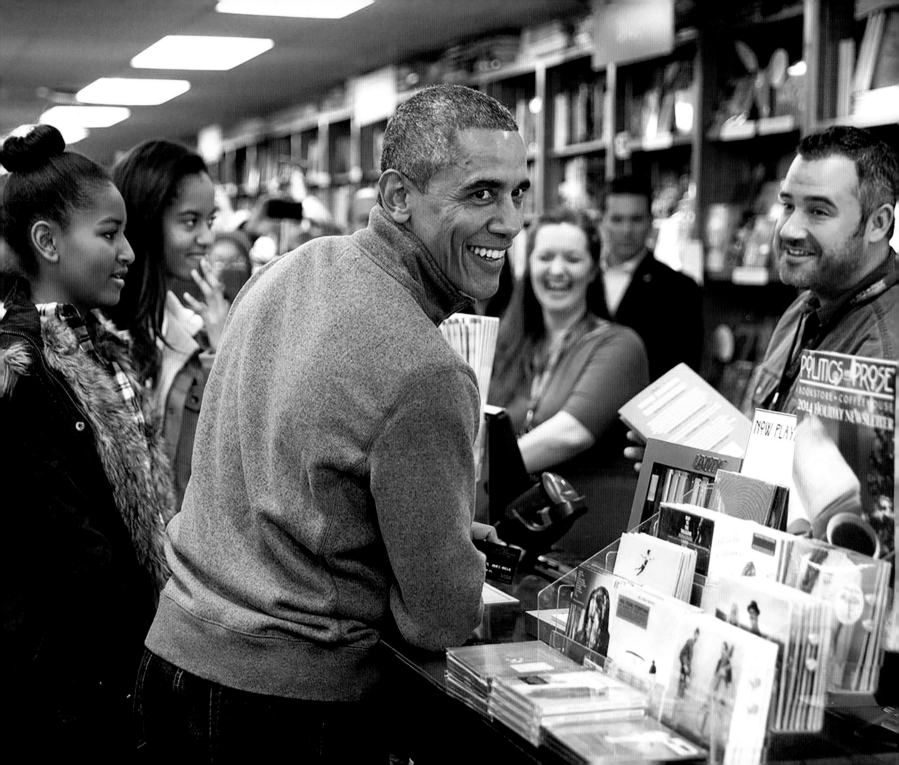

"Boys, don't get any ideas.
I have two words for you:
PREDATOR DRONES.
You will never see it coming."

—White House Correspondents' Association Dinner, May 10, 2010

"You might have heard that **SOMEONE JUMPED THE WHITE HOUSE FENCE** last week, but I have to give Secret Service credit— they found Michelle, brought her back, **SHE'S SAFE BACK AT HOME NOW.**"

—White House Correspondents' Association Dinner, April 30, 2016

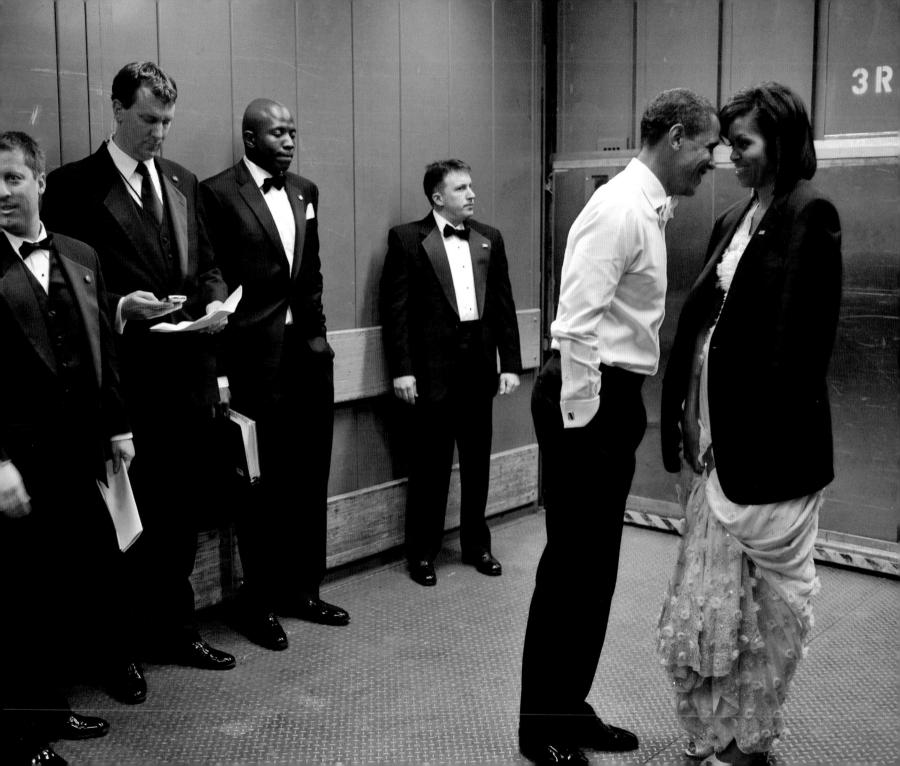

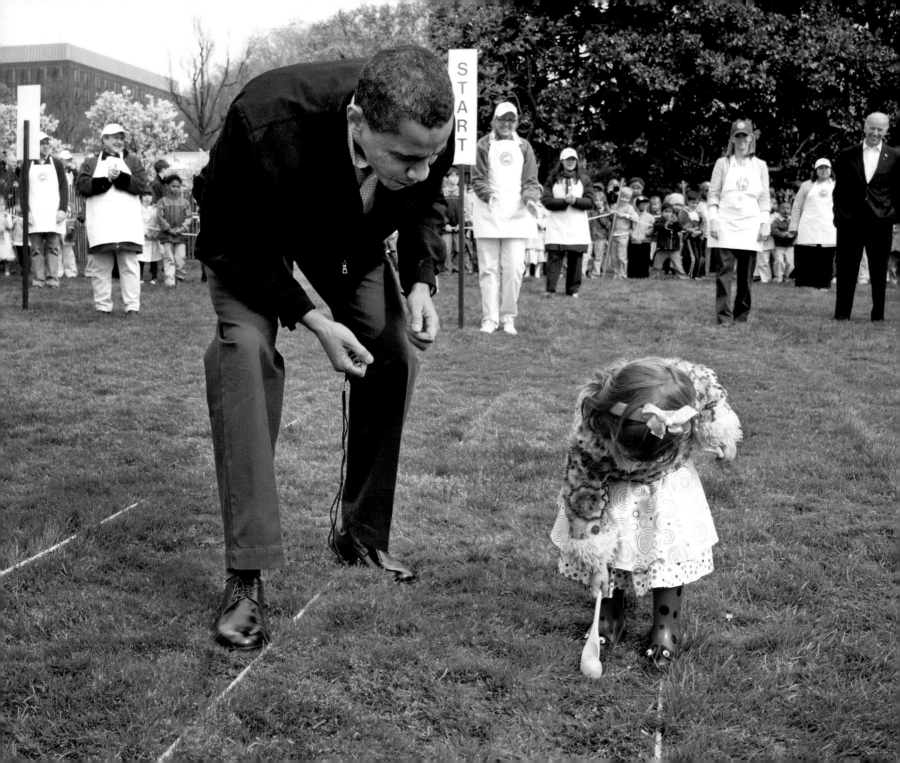

"There's someone who I can always count on for support: **MY WONDERFUL WIFE, MICHELLE**. We made a terrific team at the Easter Egg Roll this week. **I'D GIVE OUT BAGS OF CANDY TO THE KIDS, AND SHE'D SNATCH THEM RIGHT BACK** out of their little hands. Snatched them."

—White House Correspondents' Association Dinner, April 30, 2011

" I look so old John Boehner's already invited Netanyahu to speak at my funeral. **MEANWHILE, MICHELLE HASN'T AGED A DAY.** I ask her what her secret is, she says, 'fresh fruits and vegetables.' **IT'S AGGRAVATING.** "

—White House Correspondents' Association Dinner, April 25, 2015

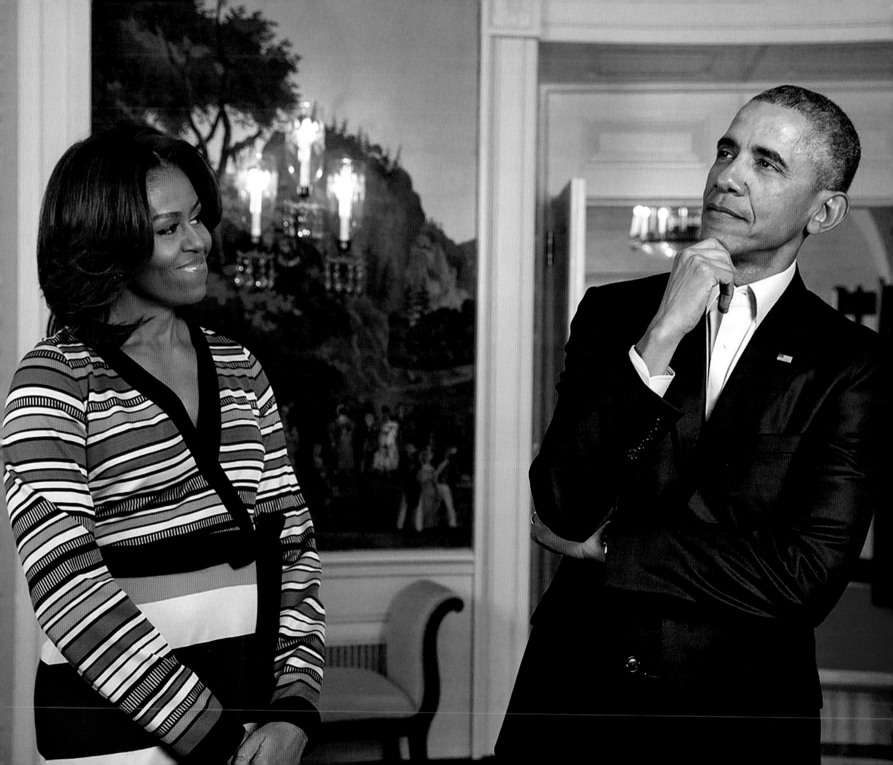

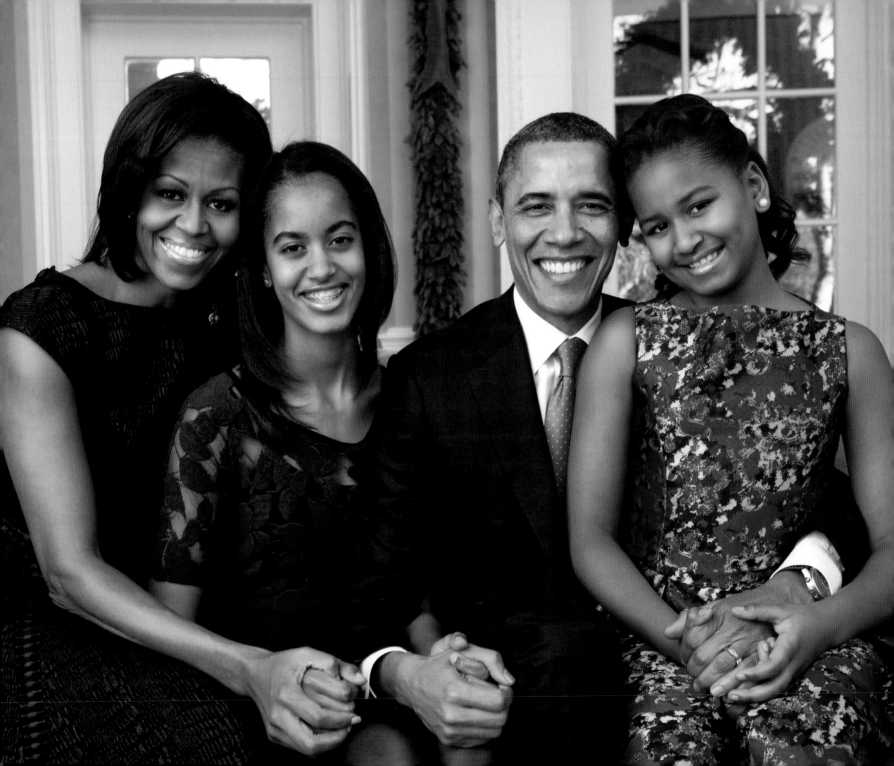

"Sasha and Malia aren't here tonight because they're grounded. You can't just take Air Force One on a joy ride to Manhattan.

I DON'T CARE WHOSE KIDS YOU ARE."

—White House Correspondents' Association Dinner, May 9, 2009

> " The truth is, after eight years in the White House, **I NEEDED TO SPEND SOME TIME ONE ON ONE WITH MICHELLE** if I wanted to stay married. "

—Paul H. Douglas Awards, University of Illinois, September 7, 2018

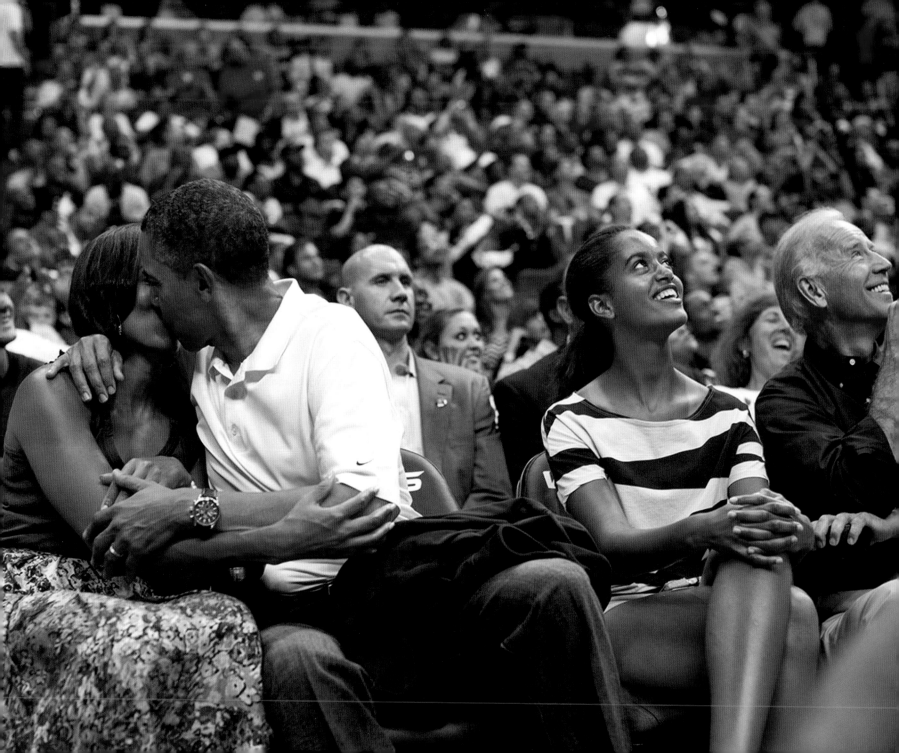

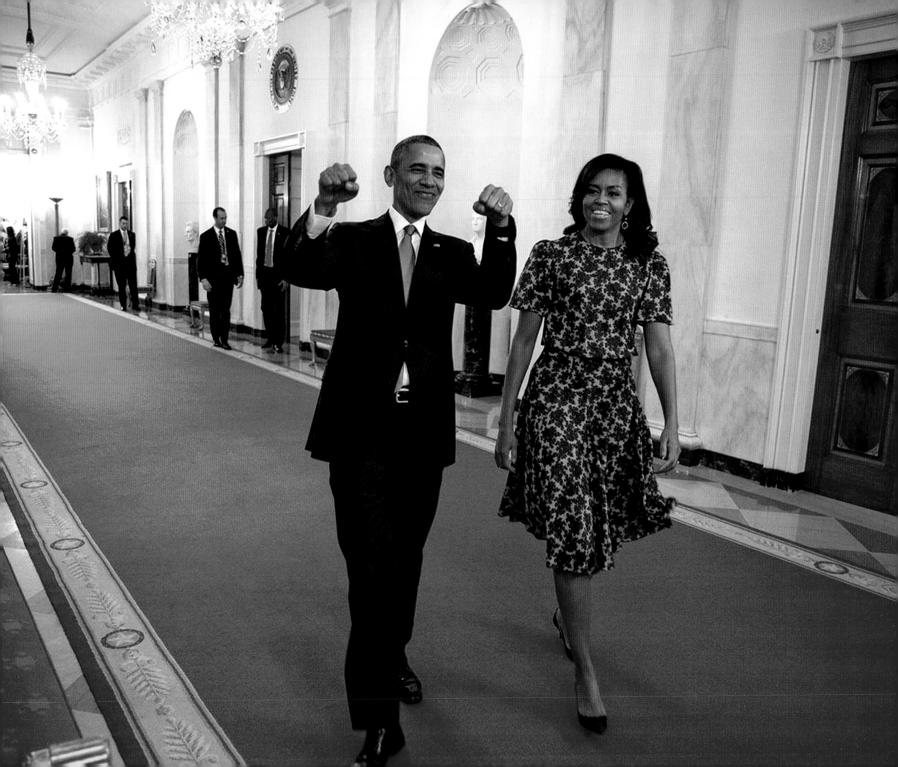

"There are few things in life that are harder to find and more important to keep than love— well, love **AND** a birth certificate."

—White House Correspondents' Association Dinner, May 10, 2010

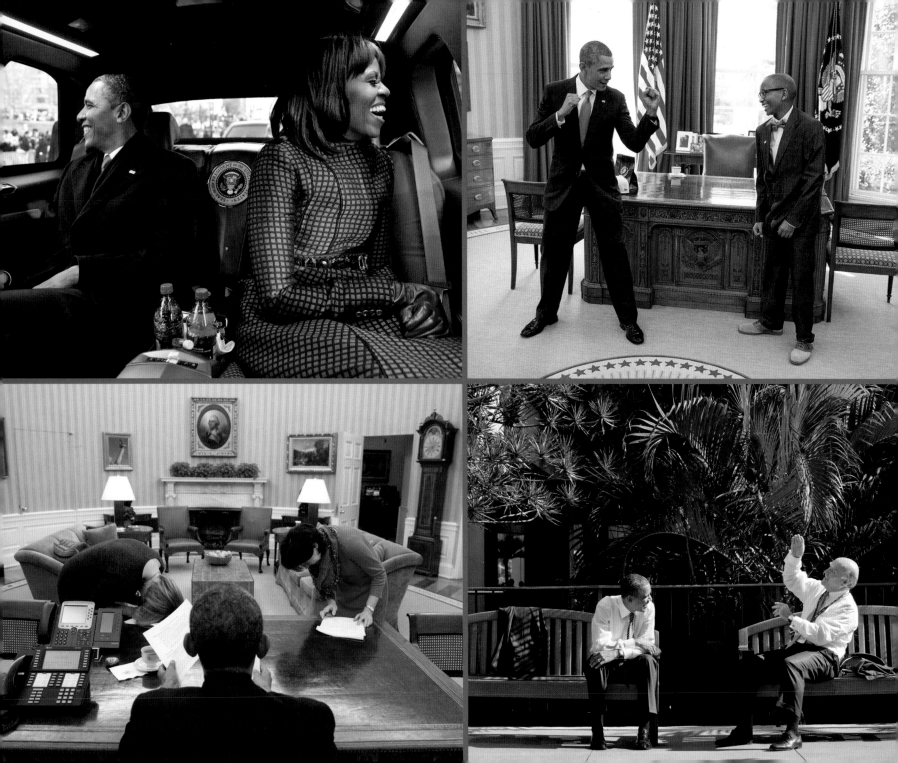

PRESIDENTIAL LAUGHS

"If I had to name my greatest strength, I guess IT WOULD BE MY HUMILITY. Greatest weakness: it's possible that

I'M A LITTLE TOO AWESOME."

—Alfred E. Smith Memorial Dinner, October 16, 2008

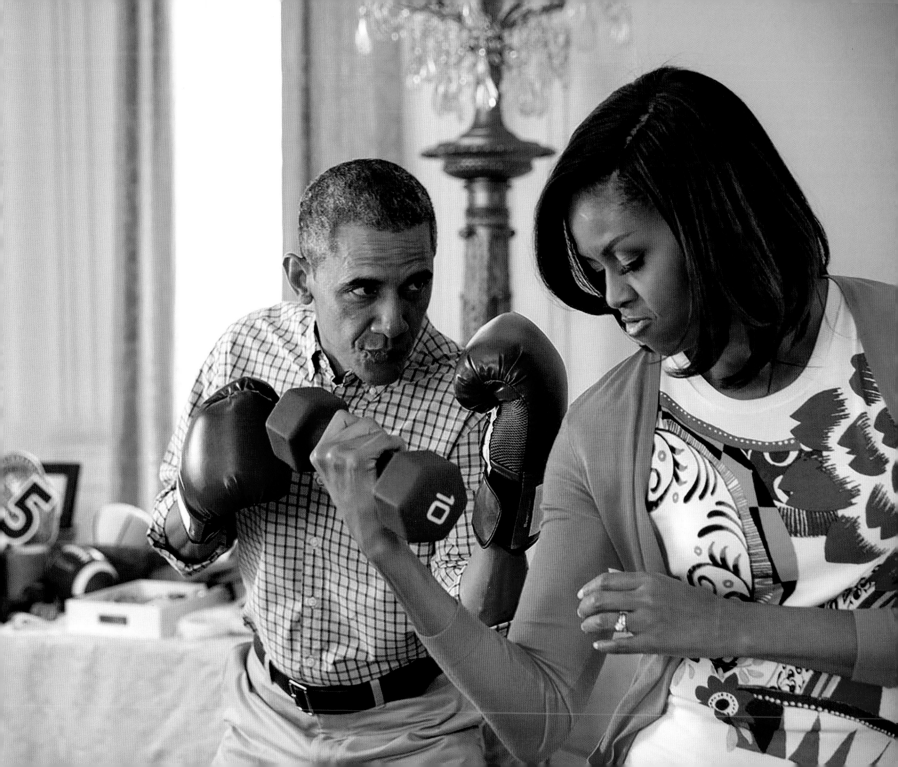

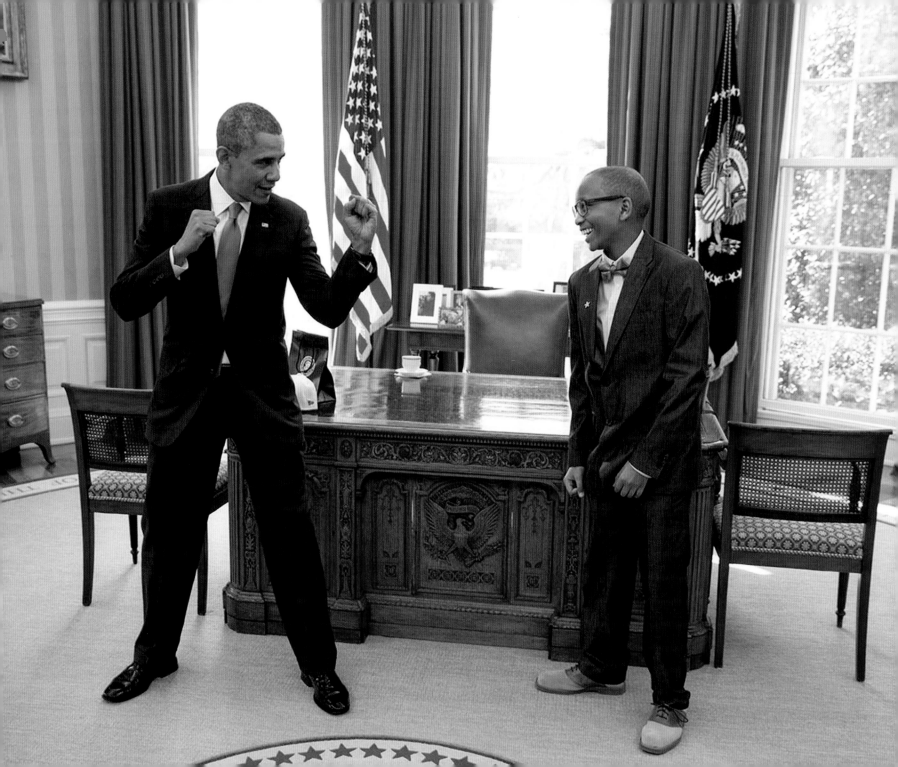

"Basically I'm here to announce that **WE'RE BUILDING IRON MAN.** I'm gonna blast off in a second. This has been **A SECRET PROJECT** we've been working on for a long time. Not really. Maybe. **IT'S CLASSIFIED.**"

—Manufacturing Innovation Event, February 25, 2014

> **"** So I can just be me?
> # I CAN WEAR MY MOM JEANS IN PEACE.
> I hate these tight jeans. **"**

—White House Correspondents' Association Dinner, Times Video, April 30, 2016

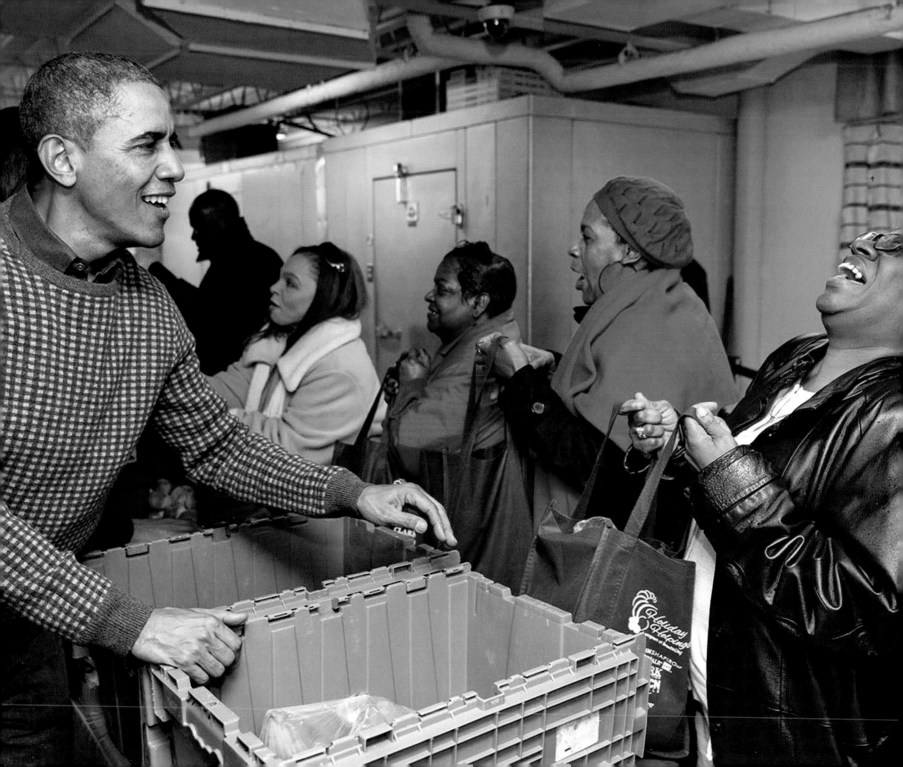

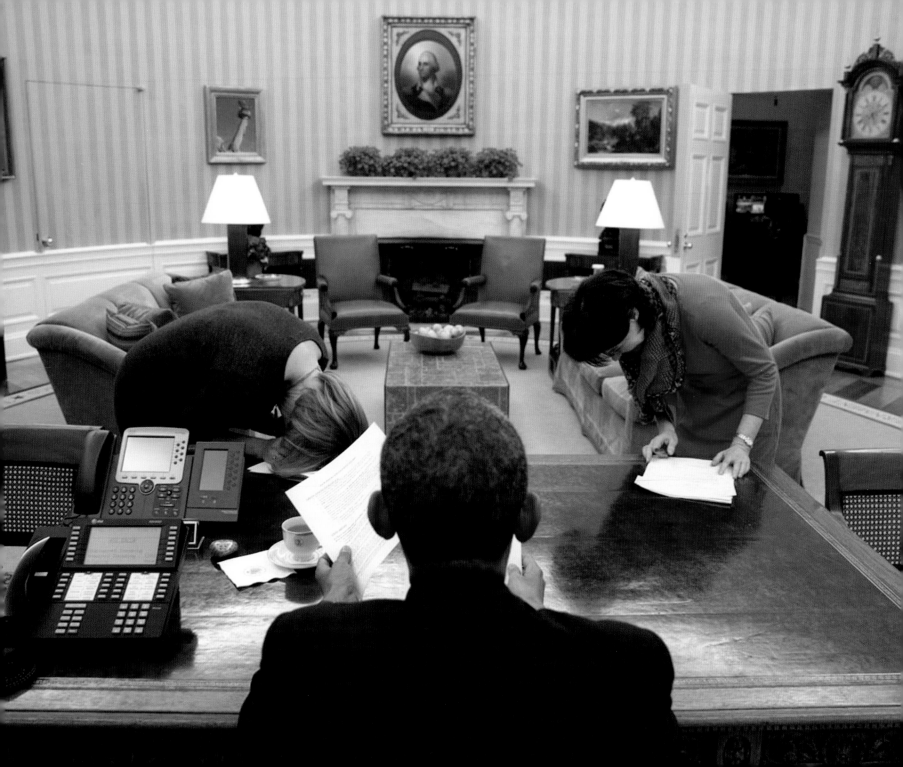

"There's a natural connection between me and DreamWorks. I don't know if you know this— but **MY EARS** were one of the inspirations for **SHREK**."

—DreamWorks Animation remarks, November 26, 2013

> " For all those who think
> I golf too much, let me be clear.
> **I'M NOT SPENDING TIME**
> on the golf course—
> **I'M INVESTING TIME**
> on the golf course. "

—Gridiron Club and Foundation Dinner, March 12, 2011

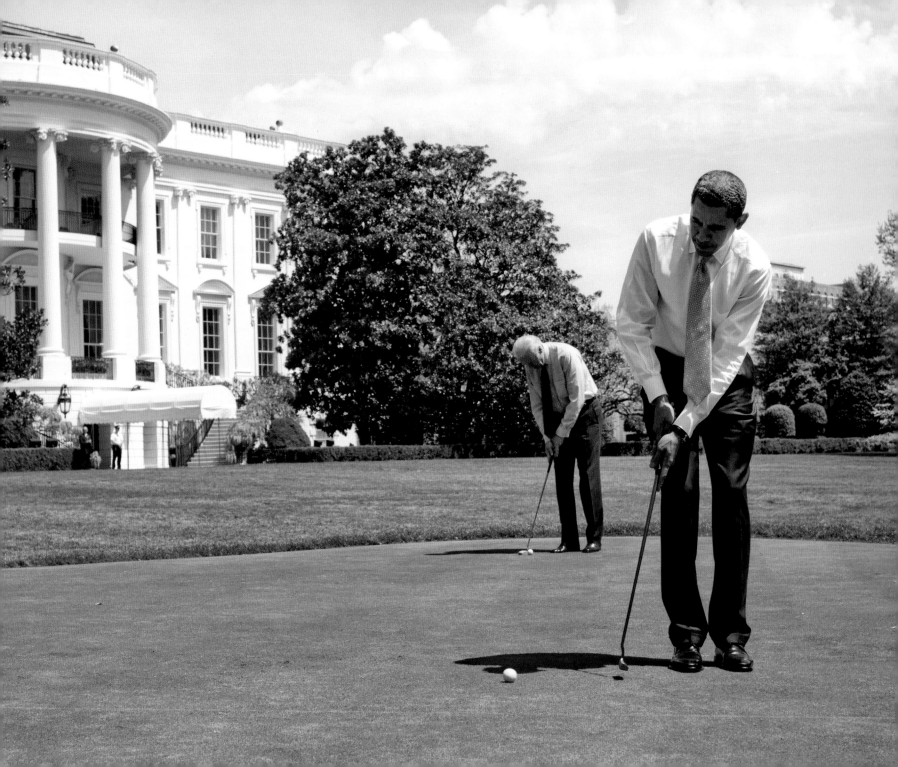

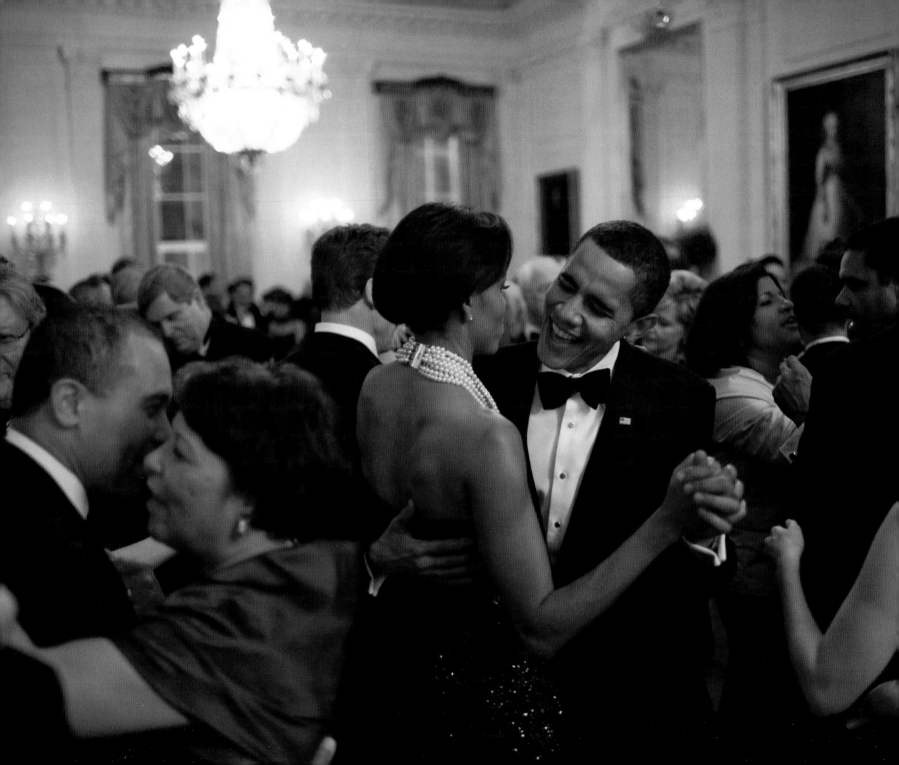

"These days, I look in the mirror and I have to admit, **I'M NOT THE STRAPPING YOUNG MUSLIM SOCIALIST THAT I USED TO BE.**"

—White House Correspondents' Association Dinner, April 27, 2013

"This is called The Beast. It's a Caddy, basically on a tank frame… **SEE, SO I COULD CALL A NUCLEAR SUBMARINE** right here from this… it's a cool feature, **PLUS SEAT WARMERS.**"

—*Comedians in Cars Getting Coffee, Season 7, Episode 1*

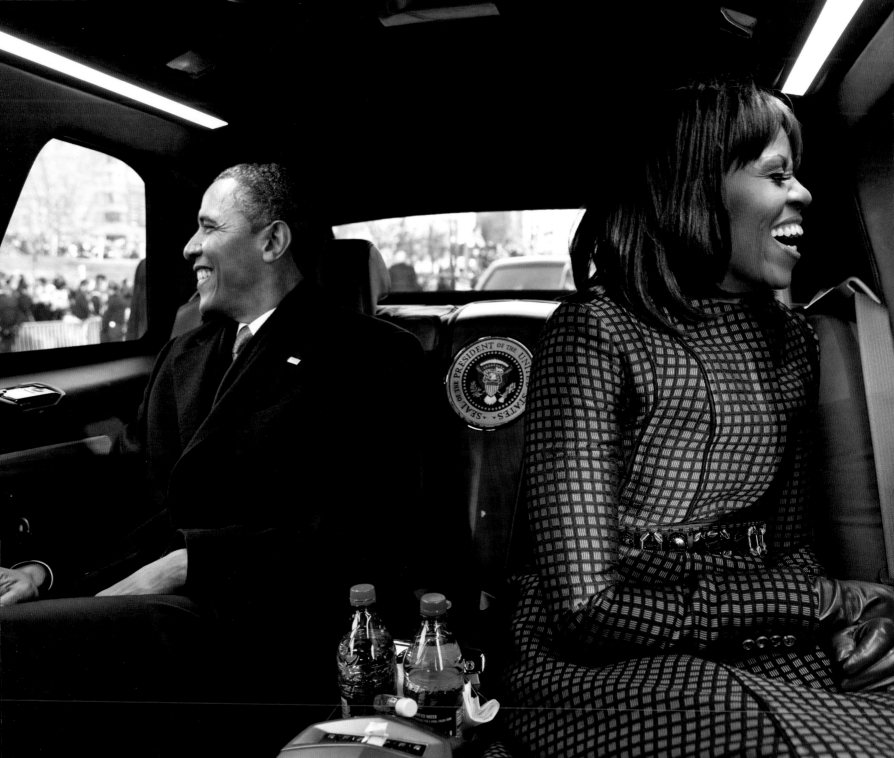

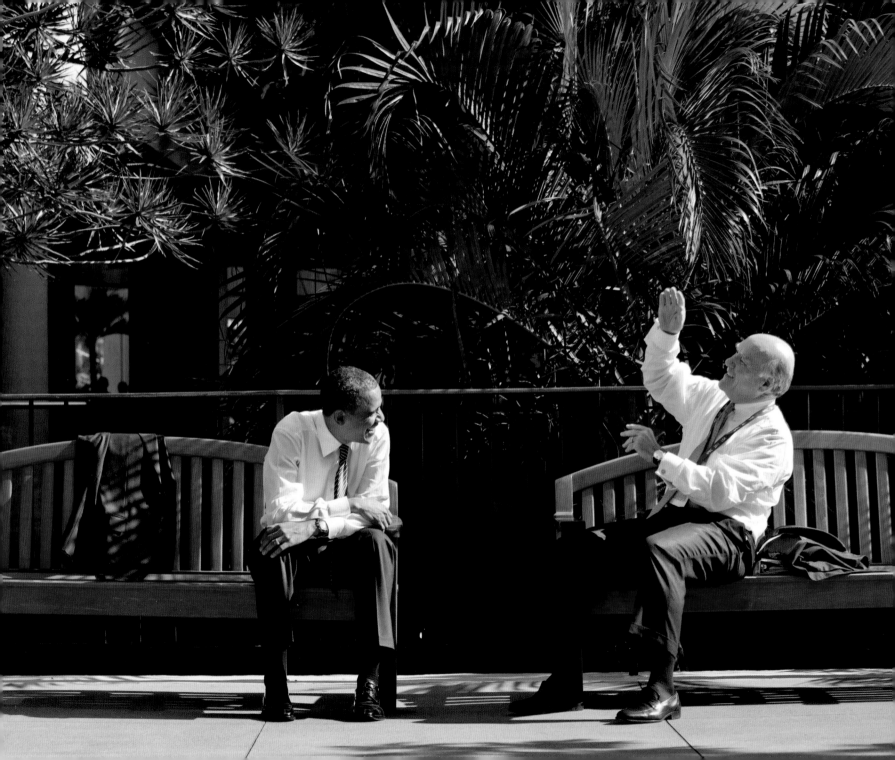

" I'm also hard at work on plans for the Obama Library. And **SOME** have suggested that we put it in my birthplace, **BUT I'D RATHER KEEP IT IN THE UNITED STATES.** "

—White House Correspondents' Association Dinner, April 27, 2013

"I believe that my next hundred days will be **SO SUCCESSFUL** I will be able to complete them in 72 days. **AND ON THE 73RD DAY, I WILL REST.**"

—White House Correspondents' Association Dinner, May 9, 2009

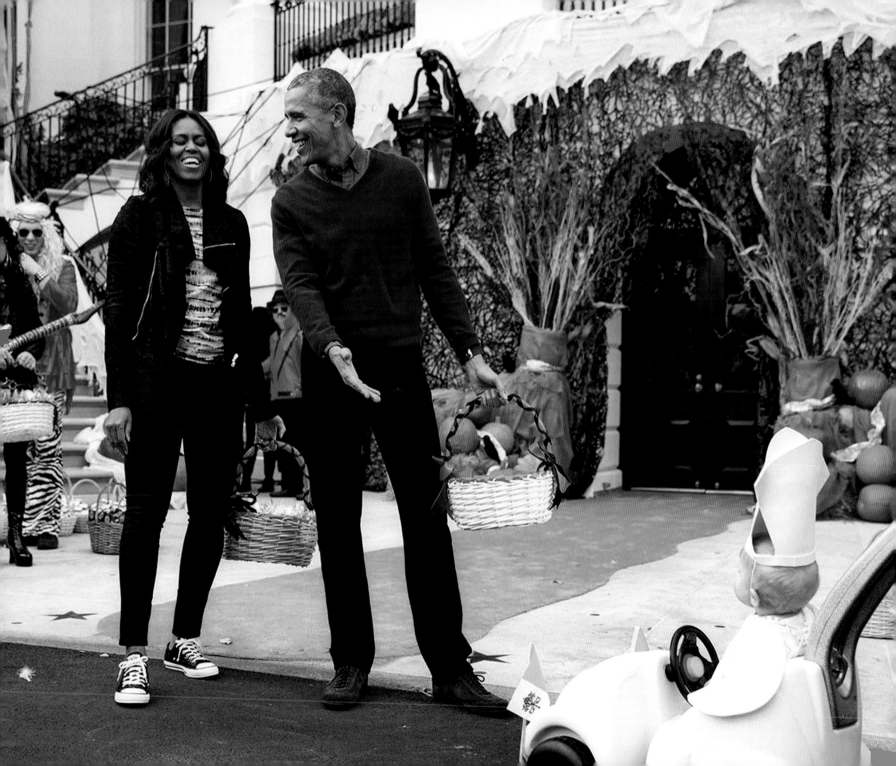

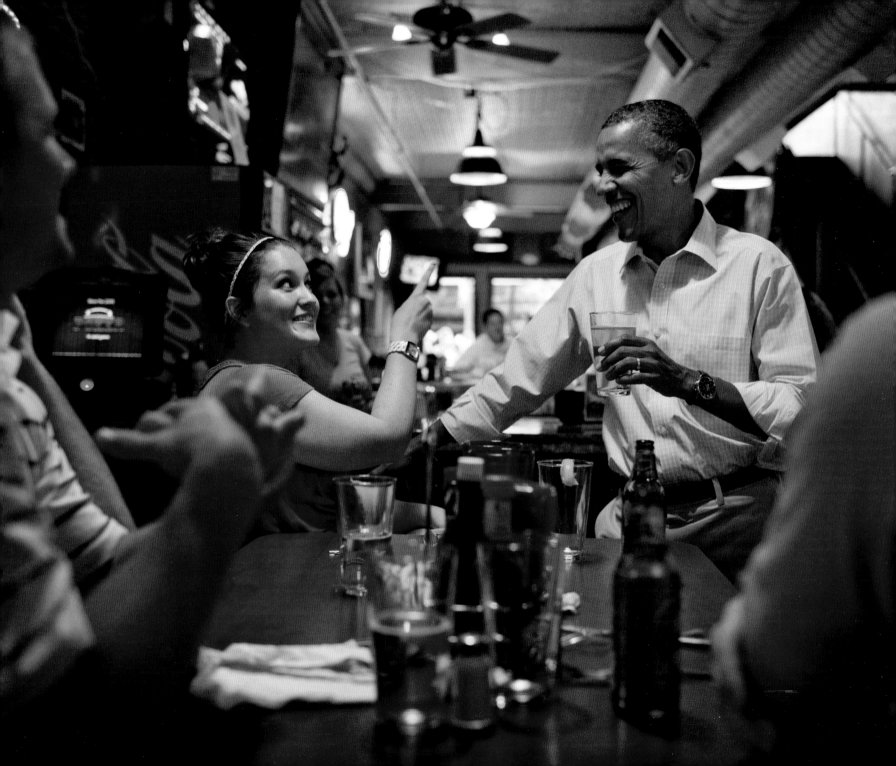

"I'm like the **OLD GUY** at the bar where you went to high school. Just kinda hanging around. Shirt's buttoned a little too low, **STILL THINKS HE'S COOL.**"

—*Jimmy Kimmel Live!*, ABC, October 25, 2016

"I have no more campaigns to run. . . . **I KNOW, BECAUSE I WON BOTH OF THEM.**"

—State of the Union Address, January 20, 2015

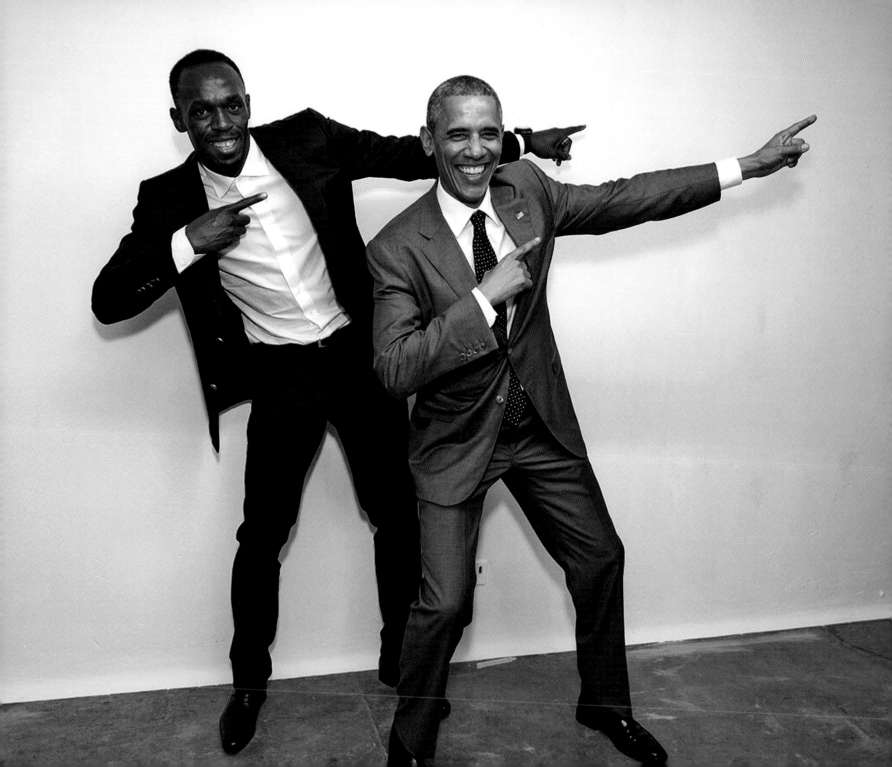

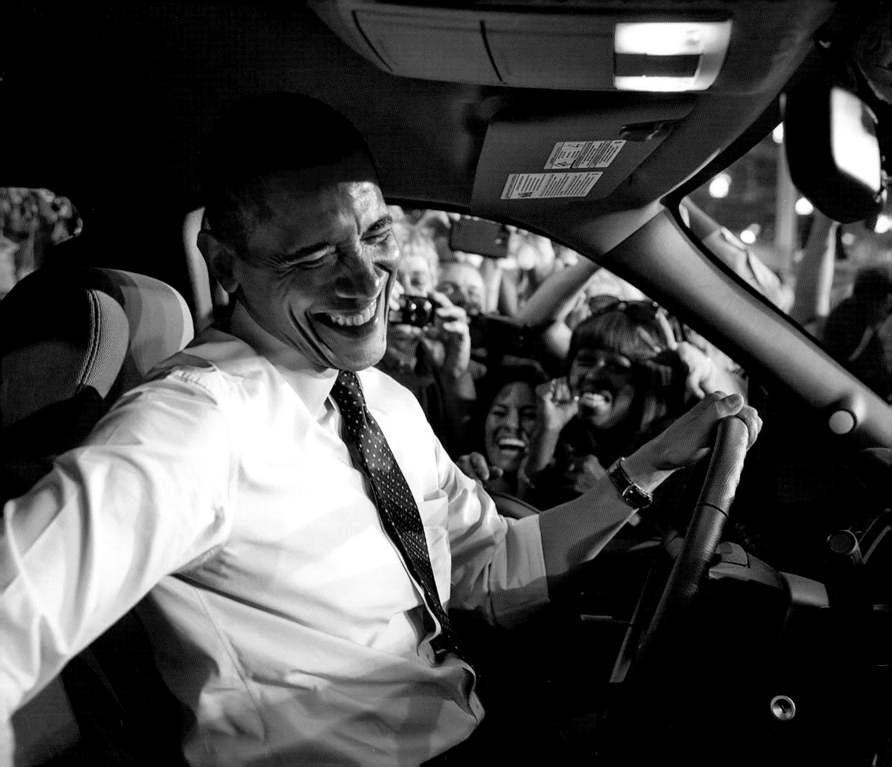

"I'M APPRECIABLY COOLER

than I was just two minutes ago."

—*Comedians in Cars Getting Coffee*, Season 7, Episode 1

"OBAMA OUT."

—White House Correspondents' Association Dinner, April 30, 2016